W9-BST-567

THE COMPLETE BEDWETTING BOOK
Including A Daytime Program For Nighttime Dryness

D. Preston Smith MD
Pediatric Urologist
Fellow of the American Academy of Pediatrics
Fellow of the American College or Surgeons
Fellow of the Society of Pediatric Urologists

Foreword By:

MiChelle Passamaneck MSN RN CPNP CUNP
Pediatric Urology Nurse Practitioner

PottyMD

Helping kids to stop and to go

DISCARDED

The content and information contained in this book are intended to help parents, physicians, and care providers with bedwetting issues. The content and information in this book does not constitute professional medical advice and should not be substituted for professional medical advice, diagnosis, and/or treatment. The author and PottyMD LLC disclaim any liability arising from use of the content contained in this book.

Copyright ©2006 by PottyMD LLC
All trademarks are the property of their respective trademark owners.

All rights reserved. No part of this publication may be reproduced or transmitted in any form or by any means, electronic or mechanical, including photocopying, recording, or any information storage or retrieval system, without permission in writing from the author or PottyMD LLC.

Printed in the United States of America

PottyMD LLC
Knoxville, Tennessee USA
www.pottymd.com

ISBN 0-9762877-7-3

Book and Cover Design: Layne Moore
Illustrations: Denise McClure

Bulk order discounts are available for medical practices, parent organizations, or other interested groups. Please contact PottyMD.com for more information.

ABOUT THE AUTHOR

D. PRESTON SMITH MD, FACS, FAAP, FSPU
Pediatric Urologist

D. Preston Smith attended Rice University where he graduated with honors in Economics. He attended the University of Texas Medical School at Houston and following graduation he spent two years in General Surgery at the University of Tennessee Medical Center at Knoxville. In 1993, he finished his Urology Residency at Northwestern University in Chicago. He concluded his training upon completion of a two-year fellowship in Pediatric Urology at the University of Tennessee at Memphis and LeBonheur Children's Hospital in 1995. Dr. Smith is board certified and he has authored or co-authored many articles, papers, chapters, and books in Urology and Pediatric Urology. His research has been presented throughout the world. He is the author of the books, *"The Potty Trainer"* and *"Overcoming Bladder & Bowel Problems in Children"*.

Dr. Smith is married and is a father of three young children. He currently maintains a very busy pediatric urologic practice. He is a fellow of the American Academy of Pediatrics, American College of Surgeons, and Society of Pediatric Urology. His dedication to helping children with urologic problems inspired him to establish PottyMD. Dr. Smith hopes through PottyMD to aid thousands of children, families, and physicians by educating them about issues related to potty problems in children.

Ventress Memorial Library
Library Plaza
Marshfield, MA 02050

JUL 27 2007

PottyMD was established in 2003 by pediatric urologists to help care providers, parents and children with all types of potty issues. We are continually studying new methods to help children overcome potty problems. We believe the products we offer are the best and most affordable available. PottyMD continues to research new educational tools and products and we will make them available as they meet our standards.

PottyMD is dedicated to helping children overcome all bladder and bowel issues including:

- Potty training
- Daytime accidents
- Bedwetting
- Constipation
- Encopresis

- Urinary tract infections
- Holding
- Belly pains and cramps
- Urinary frequency
- Urinary urgency

1-877-PottyMD www.pottymd.com

This book is dedicated to all the frustrated families who have suffered from countless wet nights and who have resigned themselves to waiting for the dry sheet fairy to visit and lay a magic cure under the pillow. Just venture inward and the answer to your problem may be waiting for you.

Acknowledgements

Many, many thanks to the nurses in my "potty" life—
Jennifer Marma, Mary Gjellum, and Kyla Melhorn-
-for their endless support and contributions to
correcting bedwetting in children. Thanks to
Denise McClure for the outstanding illustrations in
this book.

TABLE OF CONTENTS

FOREWORD .. 9

INTRODUCTION ... 11

DEFINITION OF BEDWETTING (DOCTOR TALK) 13

BEDWETTING FACTS ... 15

WHEN IS BEDWETTING A PROBLEM? 17

MOST COMMON CAUSES OF BEDWETTING 19

 TOO MUCH URINE PRODUCTION AT NIGHT 19

 ANXIETY AND EMOTIONAL STRESSORS 20

 FAMILY HISTORY ... 21

 DEEP SLEEPERS AND SLEEP DISORDERS 22

 SMALL BLADDER SIZE ... 23

 BIRTH DEFECTS AND MEDICAL CONDITIONS 24

 ABNORMAL DAYTIME POTTY HABITS 25

 DIET ... 27

ARE X-RAYS AND OTHER TESTS NEEDED? 29

 POSSIBLE MEDICAL CAUSES FOR BEDWETTING 31

TOP TEN MYTHS ABOUT BEDWETTING 33

TRADITIONAL BEDWETTING TREATMENT OPTIONS 35

 WAITING AND OUTGROWING BEDWETTING 35

 BEDWETTING ALARMS ... 36

 MEDICATIONS ... 39

 REWARD SYSTEMS ... 41

 WAKING THE CHILD TO URINATE AND LIMITING
 NIGHTTIME DRINKING ... 43

 CONSTIPATION ... 43

 COUNSELING ... 43

 ANY COMBINATION OF THE ABOVE TREATMENTS
 ... 45

CHOOSING A BEDWETTING ALARM 47

CHOOSING A MEDICATION 53

COPING TIPS FOR PARENTS 55

ABNORMAL DAYTIME POTTY HABITS CAN CAUSE
BEDWETTING ... 61

 UNDERSTANDING NORMAL POTTY HABITS 61

 UNDERSTANDING ABNORMAL POTTY HABITS 65

ABNORMAL DAYTIME POTTY HABITS AND
BEDWETTING ... 75
DAYTIME PROGRAM FOR NIGHTTIME DRYNESS 79
PROGRAM HELPERS .. 81
**WHAT I WOULD DO IF MY CHILD HAD A
BEDWETTING PROBLEM** ... 83
LAST BIT OF ADVICE FOR PARENTS 87
BEDWETTING RESOURCES ... 89
COMMONLY USED MEDICAL TERMS 91

FOREWORD

I am pleased to write the foreword for this book, The Complete Bedwetting Book, by Dr. Preston Smith. Problems with bedwetting, medically known as nocturnal enuresis, are widespread in our society. Fortunately they are not problems that seriously threaten the health of children who are affected, but they do often significantly affect the wellbeing of both the child and the family. I often tell families in my practice that the history of bedwetting should be included in premarital counseling because the parental history is predictive of what the children will experience and usually parents do not find out about their spouses former bedwetting issues until they are in the thick of the struggle and have not had time to prepare a good and planned response.

Dr. Smith's third book outlines a wonderful overview of bedwetting, including what we do know about the pathophysiology and possible treatments so that families can formulate a reasonable response and plan. I am so glad to see that there is now a resource for families that reviews bedwetting so very thoroughly. I am in complete agreement with what Dr. Smith proposes as a treatment plan, especially the idea that all children who struggle with bedwetting should start with a thorough evaluation of their daytime habits, even when there does not appear to be a problem in this area. Dr. Smith as well as many other pediatric urology providers has embraced this treatment idea and plan. This has been crucial to the success of my patients who are bedwetters and I find that this treatment is all that is needed in the majority of cases. As Dr. Smith states, even though there is medical evidence that daytime holding habits and night time wetting are related, the general medical community has not yet fully embraced this concept. Dr. Smith's book gives families this essential information which will empower parents and patients to talk to their health care providers about these things and hopefully decrease both the idea that there is a

medicine or surgery that can correct these things as well as the prescription of these medicines and the expectations of families that when they are referred to a pediatric urology specialist, that there is a surgery that will fix these problems, which there is not.

Dr. Smith's commitment to this issue is commendable and I am so glad that I have had the opportunity to be his colleague as he addresses the issues that face the millions of children in regard to bedwetting and dysfunctional elimination. Theses problems are amazingly common, but because of their nature, many families and children struggle in silence. I hope that his book will be a tool to help these families as well as all the health care providers who are giving them primary care. With this, his third book, Dr. Smith has again put forth the effort, time and sacrifice to help children and families and I would like to say thank you from the families and all the health care providers of these children for his excellent contribution.

MiChelle Passamaneck MSN RN CPNP CUNP
Pediatric Urology Nurse Practitioner

Chapter 1

INTRODUCTION

Bedwetting is a condition that affects millions of children for which there are no magic cures. The best treatments available for children and their families are provided in this book. Even with the many treatments available, it is still unknown why some treatments work and why others do not.

Bedwetting is extremely problematic for children. Some kids are frustrated about having no control over the problem, and others are embarrassed about being wet when others around them are not. Frustration and embarrassment can cause other social and family issues that are troublesome. These problems can cause a child to avoid being with other children and avoid activities that are fun. It is very unfortunate that children go through difficult times just because of bedwetting.

As parents and physicians, we need to do everything in our power to help children understand bedwetting and how it can be helped. There are many books, cartoons, and videos available that address bedwetting from several different angles. The purpose of this book is to provide a concise, to the point, and comprehensive overview about bedwetting and the different treatment approaches that are available. The most significant difference between this book and others is an alternative new treatment plan I propose for bedwetting.

As a pediatric urologist and father of three children, I have extensive experience in treating all forms of potty problems including bedwetting. I have read, researched, and practiced virtually everything that is currently available regarding bedwetting. I am passionate about my desire to educate the medical community and families about the various bedwetting issues so that we do not over prescribe testing, medications, and bedwetting products. Our goal is to get results that are quick, effective, cost-conscious, and without unnecessary medical intervention. These goals are not always possible but we must strive for the best. I hope that this book provides insight for physicians and parents on how to deal with bedwetting and

how to understand its causes. Together we can gain a new perspective about this problem that increasingly faces our children. I sincerely believe that after reading this book your treatment approach will be more directed at solving the problem and not simply trying to seek an easy way out. Sit back, read, and be open-minded about how you can better understand bedwetting and how it is best addressed for your child.

Chapter 2

DEFINITION OF BEDWETTING (DOCTOR TALK)

Enuresis (DSM-IV Classification)
- Repeated voiding of urine into bed or clothes
 1. Involuntary or intentional
- Clinically significant criteria (one of the following)
 1. Twice weekly for at least 3 consecutive weeks
 2. Significant distress
 3. Impaired function
- Age 5 years or older
- Other cause not present
 1. Medications
 2. Diabetes Mellitus
 3. Spina Bifida (neurogenic bladder)
 4. Seizure Disorder

BEDWETTING IN SIMPLE TERMS

 If it is going in here

 And it is not going in here

 And there are no other medical problems, then your child is a bedwetter.

Chapter 3

BEDWETTING FACTS

> *Bedwetting=Nocturnal Enuresis=Sleepwetting*

Bedwetting has been a problem for centuries. Medical literature dating back to the 1500's discusses issues related to urinating while asleep. It was commonly thought that children who wet at night had psychological and emotional problems. Now it is known that many different children with many different personalities wet at night, even without obvious emotional or psychological problems. Even children and young adults, who are seemingly well adjusted, wet at night. The exact cause for bedwetting is still unknown.

FACTS:
- Millions of children all over the world bed wet
- The number of children who wet at night is increasing
- Over 7 million children in the U.S. experience bedwetting
- 2/3 of kids who wet at night are boys
- 10-33% of 5-6 year olds bed wet
- 8-15% of 7-8 year olds bed wet
- Less than 5% of those older than 10 years of age bed wet
- Children whose parents were bedwetters have a 40% chance of bedwetting
- If both parents were bedwetters then the chances increase to 75% that their children will wet at night
- 20% of bedwetters also wet during the day

GOOD NEWS:
- 15% become dry each year
- 70% of children will "outgrow" bedwetting by the time they are 11 years old
- 99% will no longer wet at night by the time they turn 15
- Less than 1% of children with nighttime wetting have a medical explanation for their problem

Percentage of Young People Who Wet the Bed

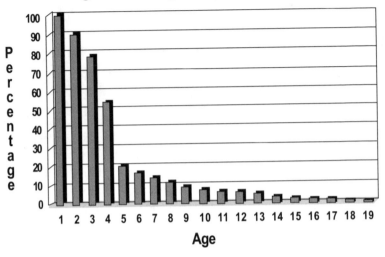

Data: Fergusson DM et al. (1986) Factors related to the age of attainment of nocturnal bladder control: an 8-year longitudinal study. Pediatrics 78: 884-890.

At Least One of These Was a Bedwetter AND
As Many as Six of These Could Have Been Bedwetters

Chapter 4

WHEN IS BEDWETTING A PROBLEM?

Being wet at night is not a problem in and of itself. The frequency or amount of wetness also does not indicate whether there is a problem. Children that wet a few nights a week and those that only wet small amounts are still bedwetters. Those that always wet at night (primary nocturnal enuresis), and those that develop new bedwetting (secondary nocturnal enuresis) are both having similar issues—they are wet and their beds are wet.

- If your child complains about wetting the bed it is a problem.
- If you complain about your child's bedwetting, it is a problem.
- If others make your child feel uncomfortable about their bedwetting, it is a problem.

If any of these statements are true, regardless of the amount or frequency of wetting, then please understand that you should address the situation because it is a problem.

If your child has had a dry night in the past and has been evaluated by a physician for bedwetting, then you should not be concerned about an underlying medical problem. Millions of children wet at night, and you should not feel that only you and your child are having this problem. Parents commonly do not worry or seek help for the bedwetting if their child is less than 4 years old. After this age, parents begin to wonder if the bedwetting will go away or begin to fear something is wrong. Children age 5 years begin to notice their peers do not wet, and they can become concerned that others may find out. As the bedwetting continues, parents become frustrated with constantly changing clothes and bedding. Sleepovers and camps are more commonplace with older children, and these can cause bedwetters to fear that they will have an accident away from home. Bedwetting teenagers get very anxious because of concerns they will be discovered, or they fear they will never outgrow the problem.

There is no magic age for determining when bedwetting is a problem. Many refer to 6-7 years of age as when a parent needs to address the problem. This age does correlate with when most bedwetting stops, and child concerns begin to mount. But this is not an age that makes bedwetting a medical concern. If you are motivated, you can start to correct the wetting before it becomes a concern for you or your child. It is possible to start measures to correct the wetting shortly after potty training. If you start young, you may have better results and avoid many of the frustrations that commonly arise. It may sound extreme to start making changes shortly after potty training, but your efforts may pay off. If the wetting is improved early, bedding and clothing issues will not be as problematic. The earlier you start the more your child will be accustomed to making the changes you request of them. The earlier you choose a certain diet, bed alarm, drinking schedule, and good potty habits, then the more likely your child will be dry. On the other hand, more extreme measures, like trying certain medications, are not usually warranted in young children (less than 5 years) who wet at night.

Remember, bedwetting that is not caused by any underlying medical problem (physical or mental) will almost always end with time. It is completely up to you and your child to decide when to start treatment for bedwetting. Most parents and physicians do not attempt to address bedwetting at an early age. If you wait until the bedwetting becomes a problem, your child may have more incentive to change, but what is required to make a difference may be more difficult. If the bedwetting extends into the teenage years, you and your child need to address the problem so that it can be stopped.

There is no magic age for determining when bedwetting is a problem. It is completely up to you and your child to decide when to start treatment for bedwetting.

Chapter 5

MOST COMMON CAUSES OF BEDWETTING

For years, many explanations have been given to explain why bedwetting occurs. Little reliable research and consistent data is currently available to support any single cause for bedwetting. There are several common theories that are still considered to be potential causes. But most likely there are several factors that cause a child to wet at night, and each child may have slightly different causes for their bedwetting. Since each child is different, and there may be several reasons for the bedwetting, it may be hard to pin down an explanation and treatment plan that is best for every child.

The more common theories include:

- Too much urine production at night = not enough antidiuretic hormone (ADH)
- Anxiety and emotional stressors
- Family history of bedwetting
- Deep sleep and sleep disorders
- Small bladder size
- Birth defects and medical conditions
- Abnormal daytime potty habits
- Constipation
- Diet

TOO MUCH URINE PRODUCTION AT NIGHT

Some believe that certain children who wet at night may produce too much urine while sleeping. They claim that bedwetting may occur because the body does not make enough antidiuretic hormone (ADH) at night. Antidiuretic hormone is a chemical that is normally made by the body that causes the kidneys to make less urine. This hormone prevents the kidneys from making too much urine during times of dehydration. Without ADH, the body would make normal or extra amounts of urine even when the body needs to keep more fluid. Some studies have shown this hormone

19

to be low at night in some children with bedwetting problems. If this were true, then bedwetters would make too much urine while they are asleep and become more likely to wet at night. Although a possible cause, most studies have not shown a definite problem with antidiuretic hormone levels in most children with bedwetting. Medication can increase ADH levels in children at night. This medication may stop or decrease the bedwetting in those with low ADH levels.

ANXIETY AND EMOTIONAL STRESSORS

It is extremely hard to identify how emotions contribute to bedwetting. Anxiety and psychological problems are hard to identify in some children, and whether these cause or contribute to bedwetting will always be hard to determine. There have been studies that have shown situational issues such as divorce, new siblings, and traumatic childhood events as being more common among children with bedwetting. It has also been shown that children with attention deficit disorders (ADD) and those with hyperactive disorders (ADHD) have increased tendencies to bed wet. About 25% of children with ADHD wet at night, which is slightly higher than the general child population.

Exactly how the variety of psychological stresses and personalities cause a child to wet has also not been determined. Abnormal daytime potty habits, deep sleep patterns, and general defiance are common in children with psychological and emotional problems. These children may be more likely to hold their urine/stool, resist recommendations to perform normal functions, and become deep sleepers because of their daytime stressors. Bedwetting is probably not caused directly by the child's emotions or behavior, but rather because of the abnormal potty habits and sleep patterns these children more commonly possess. In other words, emotional and psychological problems probably cause secondary issues that may lead to bedwetting. Addressing emotional and psychological problems may improve some of the daytime potty habits and nighttime sleep patterns that are contributing to the wetting problems.

FAMILY HISTORY

Family history is frequently discussed as a leading cause for bedwetting. Some researchers have looked for a "bedwetting gene" to explain why bedwetting seams (pun intended) to run in certain families. According to statistics if there is a family history of bedwetting, then the children are twice as likely to wet the bed. However, it is unlikely that a specific genetic or family bedwetting link exists since there is not a single cause for bedwetting.

BEDWETTING IS IN OUR FAMILY GENES

Let's look at several potential traits that could be passed from parents to children who have tendencies toward bedwetting. Parents can pass on a tendency for their children to have smaller bladders, which may increase their risks. However, not all children with smaller bladders are bedwetters. Nighttime antidiuretic hormone (ADH) levels may also be lower in certain families. Not only would this be extremely rare, but low ADH hormone levels have not been convincingly linked to families with bedwetting problems. Sleep patterns could possibly be an inherited trait, but again, not all deep sleepers are bedwetters. It is possible that several of these factors are inherited (although very unlikely), and together they may increase a child's chances of becoming a bed wetter.

Lifestyles and personality traits are commonly similar within families, which in turn can affect daytime potty habits and sleep patterns. In other words,

if a parent tends to be anxious or highly motivated then their children are likely to inherit or acquire these traits. If a parent is depressed or has psychological problems then these traits can be passed on to their children. Situations like divorce or hardships can be more common in certain families than in others. All of these lifestyles and personality traits, both good and bad, can be "inherited" and affect the way children live, use the restroom, and sleep.

Lifestyles and personalities can influence how and when a child uses the restroom throughout the day. For example, busy and distracted children and those with emotional or psychological problems commonly have abnormal daytime potty habits. These "bad" potty habits may lead to bedwetting in some children. Also, children and families that are stressed or very active during the day are more likely to burn more energy and become deeper sleepers at night. Some believe deep sleepers are more likely to wet the bed. This will be discussed in-depth later.

Physical traits, personalities and lifestyles are important factors to consider when explaining why bedwetting is more common in certain families. There are certain risk factors that can be passed from parents to their children, but nothing specific and directly linked to bedwetting has been shown to explain the increased family trends that are known to exist. Why bedwetting is more common in certain families remains a mystery.

DEEP SLEEPERS AND SLEEP DISORDERS

Parents will often describe their child that suffers from nocturnal enuresis (bedwetting) as being a deep sleeper. They will tell stories about how their child will be soaked in the bed without even waking up. If the child is taken to the restroom to pee in the middle of the night she is usually not

aware of what is taking place and she does not remember it in the morning. "My child is a sleep-walking zombie when I take her to the restroom in the middle of the night".

Studies have shown that sleep disorders such as sleep apnea (not taking normal breathes or having difficulty breathing while sleeping) are more common in those that wet the bed. Enlarged tonsils are a known cause of sleep apnea and some physicians have gone as far as to recommend a tonsillectomy (the removal of tonsils in the throat) in children with bedwetting and sleep apnea. This is not standard practice, and should be viewed as potentially aggressive treatment for bedwetting. Bedwetting alarms are used to wake a child during sleep when they wet. There is certainly some correlation between being a deep sleeper and not being aware of the need to wake up and use the restroom. It may be true that bedwetting is associated with deep sleep, but most deep sleepers are not bedwetters. Most children are deep sleepers because they are very active during the day and their bodies burn a lot of energy. Deep sleep and sleep disorders are only part of the explanation as to why some children wet the bed.

Not All Deep
Sleepers Are
Bedwetters

SMALL BLADDER SIZE

Bladder size varies considerably from child to child. Much like height and weight vary among different children and families so does bladder size. The typical bladder size of a child should be equal to their age + 2 = # ounces. So a child 6 years old should have a bladder capacity = $6 + 2 = 8$ ounces (240ml). Children with small bladders need to use the bathroom more often. This is true both day and night. Studies have shown children with smaller bladders are more likely to wet at night. There is no easy way

to measure the bladder size. The most accurate way is to place a tube (catheter) into the bladder and measure the amount it holds. It is painful to insert a catheter and kids do not tolerate it well. Since it is not usually possible to increase bladder size, this procedure should not be routinely performed.

Some doctors used to recommend holding urine for long periods of time during the day to stretch the bladder. This only caused confusion and promoted abnormal daytime potty habits because children would tighten their bottom muscles (sphincters) in order to avoid using the restroom. As a result, they would not relax long enough to let all of the pee out. A bladder that does not empty leads to other problems, including more bedwetting. Furthermore, contrary to what was initially thought, the bladder does not usually stretch and get larger with holding. The holding exercises are no longer thought to be successful in correcting bedwetting and these practices may even be harmful.

BIRTH DEFECTS AND MEDICAL CONDITIONS

There are too many birth defects to mention in this book that may affect a child's ability to normally store and empty urine at desired times. Any defect in the bladder, bladder tube (urethra), kidney tubes (ureters), and nervous system should be considered when evaluating a child for bedwetting. More than 99% of children, who appear healthy and remain dry during the day, do not have a physical defect or medical problem that would cause bedwetting. In other words, almost all isolated bedwetters do not have an abnormality of the urinary or nervous systems that causes the problem.

A pediatrician or family physician should evaluate each child who bed wets to make sure there are no obvious medical conditions to explain the bedwetting. Your child's doctor should be able to determine if a birth defect, urinary tract infection, or diabetes is contributing to the problem. A pediatric urologist or general urologist should be consulted if there are any concerns that a doctor or family may have in regards to a possible medical or physical explanation for the child that wets at night. This topic will be discussed further in the next chapter.

ABNORMAL DAYTIME POTTY HABITS

As a pediatric urologist, I have been preaching for years that children with bedwetting problems commonly have abnormal daytime restroom habits. Rarely have I had a child in my practice that only has bedwetting without any daytime potty issues. Granted I am a Pediatric Urologist who is more likely to see the most difficult cases. Most parents when asked "are there any problems during the day?" respond, "No, it is only at night." But when asked if their child during the day has to go often, has accidents, has to go quickly, wiggles or dances when she needs to go, has had a urinary tract infection, holds her urine, or has a problem with hard or large poops the parents most often respond "Yes."

Abnormal daytime potty habits are, in my opinion, one of the most common causes for bedwetting. Physicians have not yet universally accepted this theory, but research is continually pointing to daytime bathroom habits as a major contributing factor to bedwetting. Studies have shown that children who wet during the day and those with constipation have a much higher incidence of bedwetting. Kids who go often during the day (frequency) or go quickly (urgency) have also been shown to be more likely to wet at night.

It is sometimes hard for parents and doctors to understand how daytime potty habits can cause nighttime wetting. Also many people think that if a child does not wet during the day they do not have a problem with daytime potty habits. But if you think about it, children who really need to pee during the day can tighten their bottom muscles (sphincter), squat or wiggle, and run to the restroom in order to avoid having an accident. At night, these same children cannot do this since they are asleep and they cannot consciously clench their bottom muscles or run to the restroom. They can get away with holding during the day, but not at night. If a child does not take his time and get all the urine out when he goes to the potty during the day, he will most likely not completely empty his bladder prior to going to bed. The urine left behind will cause the bladder to fill up more quickly, and while the child is sleeping, the bladder will be more likely to empty.

Children with daytime urinating problems usually also have bowel problems. This is not always obvious to a parent since mild constipation is not always easily noticed. Children who do not have time or do not want to pee usually do not have time or do not want to poop. The same bottom muscles (sphincters) are tightened when one does not want to urinate or have a bowel movement. The two bathroom functions go together—if you poop you usually pee (see illustration). Since it has been shown that constipation is associated with bedwetting it is only logical that daytime potty habits (both urine and bowel movements) are also likely to be associated with bedwetting. This topic will be discussed in further detail later in the book.

SIDE VIEW

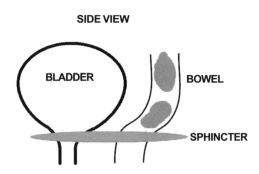

CONSTIPATION

Constipation is not well defined, and depending on whom you talk to, the definition may be very different. In children 3-12 years of age, having less than one bowel movement a day may be considered constipation. If a child has hard, large, or painful bowel movements then most agree this is constipation. Constipation usually results from a diet low in fiber, not drinking enough liquids, and holding (tightening the sphincter muscles). As stated before, children who hold their bowel movements most likely hold their urine. When investigating a child for possible constipation, one must also ask and inquire about urinating problems and habits.

Children with constipation are more likely to be bedwetters. Others claim constipation causes bedwetting because the large and usually hard stool

compresses against the bladder causing pressure and bladder emptying. If this happens while the child is asleep, then bedwetting may occur. This explanation may be true, but constipated children with huge stool in the rectum (lower bowel) do not always wet at night. Furthermore, the bladder is very pliable and the stool is not usually big enough to cause the bladder to empty. I support a more logical explanation for why constipation is associated with bedwetting—it is related to the broader problem of abnormal daytime potty habits. Children with abnormal daytime potty habits (holding) are usually constipated, and their bladders do not always empty. Their bladder may become thick and "trigger-happy" because it wants to override the child's habit of holding. A thick and trigger happy bladder that is not allowed to completely empty at bedtime will more likely empty while the child is asleep and unable to hold. **Eventually the bladder wins.**

DIET

People who treat bedwetting often advise of diet modifications. They commonly limit carbonated drinks, spicy foods, sugar, and caffeine. Some will suggest avoiding milk products and other foods that contribute to constipation. Once you read all of the foods and drinks that "should" be avoided to prevent bedwetting, there is little left that a child can eat and drink. Even with all of the diet recommendations, studies have not shown a direct correlation between diet and nocturnal enuresis. In other words, there are no direct "diet causes" for bedwetting. It is probably reasonable to limit foods that contribute to constipation if the child who bed wets is constipated. If a child has daytime potty problems then avoidance of caffeine and other stimulants (like chocolate) should be practiced as well as promoting foods that help cause frequent bowel movements. However, diet is probably not the most important factor that needs to be addressed in children with bedwetting.

Chapter 6

ARE X-RAYS AND OTHER TESTS NEEDED?

A urinalysis (urine test) should be obtained in children who wet to determine if a urinary tract infection, blood in the urine, or diabetes is contributing to the problem. The urine test is inexpensive and easy to perform. In most cases the urinalysis is normal in kids with bedwetting. If the physical exam and urine test are normal, then further testing is not usually obtained. If the urinalysis is abnormal, further testing may be advised. If treatments for the bedwetting are unsuccessful then further testing may be recommended, realizing that the likelihood of finding a significant birth defect or medical problem is very low. Your child's doctor will determine what evaluation is best for your child.

Ultrasound pictures of the kidneys and bladder are the most commonly obtained x-rays in children with bedwetting. Obtaining an ultrasound is easy, painless, and relatively inexpensive compared to other x-rays. A child who has had a urinary tract infection should have an ultrasound to determine

if the kidneys and bladder are normal. A bladder ultrasound is valuable in children with daytime potty problems. This will determine if a child completely empties his bladder and if there are any obvious abnormalities of the bladder. X-rays that involve instilling dye through catheters (VCUG = voiding cystourethrogram) or injection of dye into a needle (IVP = intraveneous pyelogram) are used to better image the bladder, kidneys, and ureters (kidney tubes). These tests are more painful and expensive than ultrasound, and should only be performed in children with infections, abnormal ultrasounds, or difficult problems.

Bladder function tests can be performed to determine if the bladder, urethra, and sphincters work normally. A child can urinate into a special potty while having small sensors placed on the buttocks to determine if the stream, flow, and sphincters are normal. A catheter (tube) can be inserted into the bladder to measure how well a child empties, how much the bladder holds, and what pressures are generated by the bladder. This test is called urodynamics. Urodynamics should only be obtained if one suspects significant abnormal bladder function due to a neurological problem or abnormal potty habits. Children with just bedwetting should not undergo urodynamics in the majority of cases.

Blood testing is not routinely obtained in children who wet. If there are concerns about diabetes or kidney function then blood tests can be useful. It is unlikely that blood tests will help healthy kids who have bedwetting problems.

Children with bedwetting problems are unlikely to have urological (kidney, bladder, and urethra) abnormalities. If your child's pediatrician or family physician suspects an underlying medical problem exists, then a referral to a specialist may be warranted. Your child's doctor or the specialist (pediatric urologist, urologist, or pediatric nephrologist) may order additional testing to make sure there are no urologic problems. As stated previously, birth defects of the urinary system and other medical conditions can cause bedwetting. Because these urologic and medical conditions are rare, x-rays, bladder function tests, and blood work should not be obtained in most children with bedwetting.

The Bedwetting Scroll

Possible Medical Causes For Bedwetting

1. Urinary Tract Infection
2. Diabetes
3. Abnormal Nerves To The Bladder (Neurogenic Bladder, Spine Problems)
4. Kidney Tubes That Do Not Enter The Bladder (Ectopic Ureters)
5. Rare Birth Defects Of The Urinary System

Chapter 7

TOP TEN MYTHS ABOUT BEDWETTING

1. Kids intentionally wet at night
2. There is a magic pill that corrects bedwetting
3. Punishment helps a child stop wetting at night
4. Most bedwetters have a true medical problem
5. Nothing helps—you just have to outgrow it
6. Only bad or lazy kids wet the bed
7. Bad parenting causes children to wet at night
8. One thing or one problem causes bedwetting
9. All children wet at night for the same reason
10. Expensive programs can provide easy and instant cures

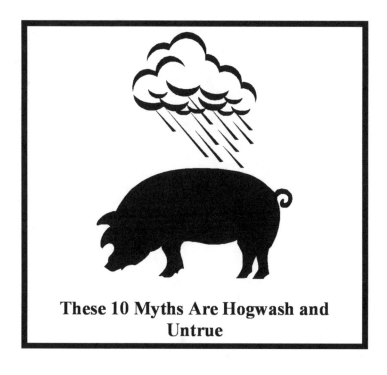

These 10 Myths Are Hogwash and Untrue

Chapter 8

TRADITIONAL BEDWETTING TREATMENT OPTIONS

There are several correct ways to address bedwetting in children. The following are the more commonly used treatment options for bedwetting in children:

- Waiting and outgrowing bedwetting
- Bedwetting alarm
- Medications
- Reward system
- Waking the child to urinate
- Limiting nighttime drinking
- Treating constipation
- Diet
- Counseling
- Any combination of the above treatments

WAITING AND OUTGROWING BEDWETTING

The simplest "treatment" is no treatment. Once you are convinced there is not an underlying medical problem causing the bedwetting then with time the bedwetting should stop. In other words, since most children outgrow bedwetting, you can simply wait and be patient for your child to stop wetting. You should be prepared to take care of wet sheets and pajamas for an extended period of time. It may take several months or several years. Both the parents and the child must feel comfortable with the decision to do nothing. Oversized pull-ups can be used but may cause your child to feel like a baby if used routinely for a long period of time. If the bedwetting continues past 6-7 years of age, you will need to address some of the social issues that may arise because your child wets. Sleepovers and childhood camps may become an issue for you and your child. If at anytime you or your child thinks the bedwetting is becoming a problem,

then you should probably change your course of action and pursue a "real" treatment.

BEDWETTING ALARMS

Bed alarms that detect nighttime wetting have been available for many years. The original bed alarm was a mattress sensor that was connected to a doorbell device. Bedwetting alarms make noise, light or vibrate when exposed to wetness (urine). When the child wets, a sound is usually made in hopes to wake the child before the bladder has completely emptied. The sound is supposed to be loud enough and quick enough to wake the child prior to complete bladder emptying. In reality this does not often occur. What usually happens is the child wets and the alarm sounds. The child (usually the parent) then awakens and the child goes to the restroom to completely empty the bladder of any "left over" urine.

Using the alarm for days or weeks and awakening just after wetting should eventually "condition" the child to wake up prior to wetting. Once you establish a consistent pattern of waking during the night prior to wetting then you graduate from the alarm. Current bedwetting alarms have sensors that are placed in the underpants or on top of the bed. Usually wires connect the sensor to an alarm or vibration device that is secured to the pajama top or near the child's ear. There are many alarms from which to choose. Some are louder than others, and some are wireless. Several options of alarms are now available to include different tones, lights, vibrations, and colors.

The most common bedwetting alarms for children use a sensor that is placed in the underpants. These sensors can be difficult to position and may require a snap or sewing the sensor into the underclothes. Unless you are fortunate to have a wireless sensor, a wire is then attached to the sensor that connects to the alarm device. Some bedwetting alarms offer separate sensors for girls and boys. Usually the more durable sensors are thicker and potentially more uncomfortable than those that are less durable. Sensors differ in size as well; some are cumbersome and heavy and others are light and delicate. A moisture sensor in the underpants can be difficult to position, but when it is in close proximity to the urethra (privates) then it

is more likely to detect even the smallest amount of leakage. These devices can still be used in children wearing diapers and pull-ups. These "sensor-in-the-underwear" alarms are the most commonly used bedwetting alarms.

Bedwetting moisture sensors are also available as a pad that fits on top of the mattress sheet. The pad detects urine or moisture and a wire (or wireless) connection then alerts an alarm to sound. The alarm can usually be placed near the pillow, pajama top, bedside table, or near the parent's bed. The mattress bed pad sensor does not require the child to wear anything. It is easier to use (for the child), especially when placed on top of waterproof sheets and inside a pillowcase. The amount the child wets and the position in which the child is sleeping may determine if the pad sensors detect any urine. If the pad is not under the child, because of movement, it may not detect the wetting episodes. Once wetting occurs the sheets may need changing and the sensor cleaned and dried. These devices are popular in nursing homes and in situations where changing bedding is important. This device is preferred when a child refuses to wear a device. In summary, the child may prefer the pad and alarm system, but the parents need to be more prepared for changing the sheets.

Studies have shown bed alarms to be safe and effective in correcting bedwetting in 50-85% of children. **Bedwetting alarms are the most successful of all conventional and commonly used bedwetting treatments.** The success rates are, however, dependent on several factors. The most important factors for success are the amount of parental and child involvement and motivation. Bedwetting alarms are not always quick fixes. They usually require parent and child working together for several weeks. Often times the child does not easily awaken, and the parents and other family members are awakened by the alarm. If the alarm is only tried a few times then it is not likely to work.

The child should be willing to use the alarm, and be prepared to try it for several weeks or months in order to get optimal results. Parents will often need to get up quickly to have the child go to the bathroom. Some experts even recommend the parent set up a temporary bed in the child's bedroom so they can wake up and more readily help their child when the alarm sounds. The child must be taken to the restroom when the alarm

sounds regardless of how much wetting has already occurred. Parents should share the responsibility of getting their child to the restroom and changing the clothes and bedding. In other words, if only one parent is doing all of the middle-of-the-night work, then resentment and frustrations (between the parents) will begin to interfere with success. Ideally, pull-ups and diapers should not be worn so the child can feel the wetness, and develop a sense of when to wake up at night.

Tips for using a Bedwetting Alarm

1. Get your child to be excited or willing to use it
2. Make it an every night routine
3. Do not skip nights or just use it in special cases
4. Make sure you (parent) can hear the alarm
5. Try to make the alarm as comfortable as possible
6. Do not let the amount or frequency of wetting discourage you from using it
7. Make sure the tone and volume are accurately set
8. Make sure the sensor is secure to the underwear or pull-up. It needs to be in the "line of fire".
9. If using an alarm with wires, position the wires inside a shirt
10. Change batteries often
11. Help your child set and position the alarm
 Avoid using diapers or pull-ups—your child should feel the wetness

If the bedwetting alarm does not provide satisfactory results after several weeks (6-8 weeks) of use then you may want to consider using it in conjunction with other standard treatments. There is no reason why an alarm should not be combined with other proven methods for improving or correcting nocturnal enuresis. **If you spent the money on an alarm keep using it for as long as you can—get your money's worth.** For example, if a reward system is also implemented, the child is more likely to

accept the process and strive to be dry. If medications are also given that either decrease urine production (desmopressin) or alter bladder function (oxybutynin, imipramine), then improved dryness may be achieved. If parents work to improve daytime potty habits, then the alarms are more likely to be effective. Limiting nighttime drinking-2 hours prior to bed time-may also give better results.

MEDICATIONS

Medications have been used for years to correct bedwetting. Unfortunately, there have not been any new medications introduced for over ten years and the ones currently available provide mixed results. There are three common medications used and each has a separate mechanism of action. They are relatively safe, but their results have been discouraging. Medications are easy to give and do not require the work required of the other bedwetting treatments. Many parents desire the "magic pill", but unfortunately it does not exist. Some physicians will routinely prescribe medications to see if they will work. Some children may experience a placebo effect (like taking a sugar pill) and become dry for just a few days after starting the medication. Since, the majority of children do not become dry with medications alone; physicians are now turning to better alternative treatments. It is safe to say, like in most health-related conditions, that medications should be avoided whenever possible. We will briefly discuss each of the three most common medications used for the correction of bedwetting. These medications should be prescribed by a physician who will see your child through the treatment process, and not by someone merely attempting to provide the magical cure. Make sure you are aware of the potential side effects and determine an end point for taking the medication in case it does not make your child dry.

DESMOPRESSIN (DDAVP)
Desmopressin (DDAVP) has probably gained the most notoriety for its effectiveness in treating bedwetting. Desmopressin is an antiduretic hormone that when given at night is supposed to decrease urine production while the child sleeps. Understandably, children who make less urine at night are less likely to wet. It is a relatively safe medication with few significant side effects. Few children have developed severe electrolyte problems (examples = sodium and potassium) when taking this medication. It is a

prescription medication and it should not be used without full consent from your child's physician. Desmopressin is available as a tablet and is quite expensive. Some children may need to take the medication for several months in order to gain full benefit.

The biggest problem with desmopressin, or any medication for bedwetting, is that it is not a "magic pill." Parents should not expect a high success rate with this drug if nothing else is done about their child's bedwetting problem. The published success rates for desmopressin range from 10-60%. Most physicians believe the medication cures bedwetting (nocturnal enuresis) in about 20% of children. Once the medication is stopped, chance of relapse is high. For this reason, some children may need to take the medication for several months. Desmopressin is very helpful for the child who is about to go to camp or have a sleep over and for whom a "quick fix" is needed. This medication is the only drug that offers a quick response time suitable for these types of situations. While using desmopressin, it may be wise to add a bedwetting alarm, reward system, treat underlying potty habits, or wake the child during the night in order to get the best results.

IMIPRAMINE (TOFRANIL)
Imipramine (Tofranil) is another commonly used medication for bedwetting. Imipramine has several actions that may help with the bedwetting problem. It is an antidepressant that has some psychological benefits. Because bedwetting is more common in children with psychological and emotional stressors, imipramine's antidepressant characteristics may be beneficial. Some physicians believe that imipramine also alters the level of deep sleep and thereby helps bedwetting.

Imipramine also changes bladder functions. It has two mechanisms of action 1) it relaxes the bladder muscle and 2) it tightens the sphincter (bottom muscles) muscles. Imipramine's success rate is also around 20%. Oftentimes, relapses occur after the medication is stopped. Imipramine is inexpensive and comes in a generic form. It can be used for short periods with minimal side effects. Imipramine can cause severe sleeplessness, weight loss, and hair loss. It cannot be taken by children with certain heart problems. Overdoses can be fatal and therefore the drug must be locked up or placed

out of reach of children. It is a prescription medication, and a physician must monitor its use. If taken for longer periods of time (greater than several weeks), it is advisable to stop the medication by weaning the dose slowly. Due to its side effects, children taking imipramine should abide by their physician's recommendations.

OXYBUTYNIN (DITROPAN)

Oxybutynin (Ditropan) has been used for many years by pediatric and general urologists for bladder spasms. This medication has the ability to relax the bladder during sudden and frequent urges to urinate. It is a very effective medicine in people that have urinary frequency (urinating often) and urinary urgency (sudden desires to urinate) during daytime hours. Although probably not as good as desmopressin and imipramine, oxybutynin has been used for bedwetting with some success. Oxybutynin may allow a child more time to wake up when the bladder gets full and thereby avoid a sudden wetting accident. It may also increase the "functional bladder capacity" (bladder size) during sleep. The more common side effects of oxybutynin include dry mouth, constipation, facial flushing, and even hallucinations. Overall, it is a relatively safe medication. Oxybutynin is also a prescription medication that requires monitoring by a physician.

REWARD SYSTEMS

Children always respond to praise. If you want your child to perform a particular task, give them a hug, kiss, or word of encouragement and they will likely do what you ask. Bedwetting can be improved if your child is rewarded for the dry nights. The biggest problem with rewarding dry nights, and not rewarding wet nights, is children hardly ever intentionally wet the bed. Therefore, if you reward them for dry nights you are rewarding them for something they feel they have no control over. On the flip side, if they wet and do not receive a reward, then they might feel disappointed or punished for something that is beyond their control. As a parent you must approach the rewards for dry nights carefully.

If you are going to reward your child, you must explain that you are never mad or upset if they wet. Every bedwetting child wants to be dry and he

should not feel ashamed or embarrassed when he is wet. Rewards should be explained as being an extra benefit for being dry. There should be no consequences (except for helping with the soiled sheets and clothes) for being wet. The rewards should not be expensive or extravagant. If they are, the child will be especially disappointed if he is wet. The rewards should be small and simple—extra hugs, kisses, and praise is good for starters. Giving a child extra time to do his favorite activities is another good idea. A child that is dry may get "extra" benefits, but a wet child should still be given hugs, kisses, praise, and some time to do his favorite activities.

The most common reward system is a calendar and stickers. The calendar is good because it allows you and your child to see trends and progress. The stickers are usually positive signs for a dry night. Stars, animals, or complimentary words are excellent sticker choices. Ideally the stickers should be placed on the day of the month or week when the child wakes up. This should be a private time between you and your child so you can talk positively about what happened even if they were not dry. If your child is embarrassed by having a reward calendar then hide it or choose a regular calendar and label system that is less noticeable. You can choose your own reward system but make sure you do not "bribe" your child to become dry. It is probably not a good idea to reward a child with candy or toys except if a special circumstance arises. If the rewards are too exciting or too fancy then your child may try to hide the wetting or they may forget to focus on the more important aspects of treating their bedwetting problem.

Reward Ideas
Hugs, Kisses, Praise • Extra time on computer or game •
Small toys or items • Special movie • Special food or restaurant

WAKING THE CHILD TO URINATE AND LIMITING NIGHTTIME DRINKING

Drinks should probably be limited several hours before going to bed in all children with bedwetting. The general rule is to stop drinking 2 hours before going to bed. It is usually helpful to wake children in the middle of the night to use the restroom even if they have not yet wet. Randomly awakening a child will not condition them to wake when she wets, but it may prevent wetting. It can be a frustrating task to wake a child to use the restroom only to have them still wet the bed a few hours later. This is unavoidable in some, but for others waking them to pee will help them be dry. Limiting nighttime drinks and waking your child to urinate in the middle of the night are simple measures many parents should try to see if dry nights could be achieved

CONSTIPATION

Constipation, in and of itself, is more of a medical concern than bedwetting. A child who is constipated may have belly pain, poop accidents (encopresis), and other medical problems that warrant attention. Constipation is associated with bedwetting, and needs to be treated along with other potty habit problems. As I mentioned earlier, you should work on daytime potty habits and address constipation when attempting to correct bedwetting. Using a bedwetting alarm (or any other treatment) along with correcting the constipation will be more effective in stopping the bedwetting than strictly addressing the constipation problem alone. There are several ways to address constipation. Usually a comprehensive bowel program is required. Consult your child's physician if there are any questions. Diet consisting of increased fiber and fluids will help. Avoidance of large quantities of dairy products and other constipating foods is advised. Usually the use of low-dose laxatives and instructing the child to use the bathroom often are usually necessary. The goal is to correct constipation and prevent relapses. This usually requires using low-dose laxatives for several weeks. Constipation should be addressed in all children, especially those who wet at night.

DIET

Diet influences many medical conditions and certain foods and drinks may also affect bedwetting. It is very difficult to determine if any particular diet or foods significantly influence the likelihood of a child to wet at night. Many foods and drinks have been named as contributing to bedwetting. Children with bedwetting and abnormal daytime potty habits should probably not consume caffeine, or other stimulants such as chocolate. Also, children with constipation should limit dairy products, until the constipation is corrected. Carbonation and spicy foods have been suggested to contribute to bedwetting, but there is not enough medical proof to implicate these as being problematic. Sleep habits and bladder function can be influenced by certain foods. But, since the cause for bedwetting is unknown, diet is not yet considered a main contributor. Altering a child's diet to help correct bedwetting is reasonable, but suggesting that diet can cure bedwetting is probably far-fetched.

COUNSELING

Counseling can be extremely helpful for children and parents faced with significant bedwetting problems. Children with learning disabilities, developmental delay, and attention deficit disorders are more likely to wet at night. Professionals that are very knowledgeable about the diagnoses and treatments of these problems can provide significant insight and help parents understand their child's situation. Professional counseling is very important when psychological problems exist that affect the day-to-day life of a child. Bedwetting can be very closely tied to underlying psychological issues, and for this reason counseling can be very rewarding.

Children who have experienced divorce, death, a new sibling, or a new school can have issues that significantly influence their ability to be dry at night. Family counselors, family physicians, pediatricians, and school counselors can be helpful in identifying or discussing these issues. Once the issues are known, then children are more likely to get the comfort, attention, and guidance they deserve in order to better deal with their concerns.

Medical counseling can help parents and families better understand all of the various treatment options available to correct their child's bedwetting. Bedwetting can be a very confusing issue with many treatment approaches. Families can disagree on the approach and leave the child in the middle without getting a fair chance at any one treatment. With a little guidance, kids, parents, and family members can get better results if a trained professional guides them through the options for treatment. Also, since compliance to treatment is very important for success, counseling serves to keep everyone on track so the bedwetting can be corrected more quickly. Please obtain advice from someone who understands all of the treatment options for bedwetting. Good medical counseling can prevent a family from spending money foolishly on various schemes, products and medications that are unlikely to help your child.

ANY COMBINATION OF THE ABOVE TREATMENTS

The traditional treatments for correcting bedwetting can be discouraging for many parents. The success rate from any single treatment option ranges from 10-75 percent. Since many treatments do not meet the expectations of parents and children, alternative methods should be tried. If another treatment approach also fails, then a combination of treatments should be tried. Children with significant bedwetting problems may require implementing broad approaches that address many of the different possible causes. For these reasons, many pediatric urologists believe that a combination of treatments should be pursued during the initial treatment plan.

Better results are obtained when implementing several different treatment methods at the same time. Trying a bed alarm and a reward system together will give better results than using the alarm or reward system alone. Medications are also more successful when combined with other treatments. Rewards, alarms, addressing constipation and other methods are very useful in children who do not respond to the medications alone. Counseling is always a good addition to any treatment plan. Understanding what emotions and problems your child is experiencing will commonly help the bedwetting program you choose. Many different combinations can be tried, since the various treatment approaches work in unique ways.

You, your child, and your child's doctor will need to team up and conquer this problem in a way that might require several approaches at the same time or over a period of time.

Chapter 9

CHOOSING A BEDWETTING ALARM

Remember, before you buy an alarm make sure you are willing to wake with your child and be patient with the process (it may take days or weeks). Each of the alarm systems functions in the same way by waking the child or parent when wetting occurs. For this reason, you will want a loud alarm (vibration hardly ever works). Your child will then need to use the restroom even if wetting has occurred. Fresh underwear or pull-ups should be used after wetting. The alarm device should be cleaned and dried before repositioning and using again. A continuous record of dry and wet nights should be kept. You may see progress immediately or it may take several weeks before dry nights occur.

Once you decided you would like to try a bedwetting alarm, purchasing the correct device for you and your child is important. The first decision to make is whether to use a mattress pad or undergarment sensor. If your child moves a lot in their sleep or does not mind wearing the alarm, then the undergarment sensor would be the best choice. If your child does not like wires and electronic devices then a wireless alarm should be used. If you do not wish for your child to wear a device, or if your child refuses to wear a device then a bed pad and alarm system can be used. The mattress pad sensor is usually the size of a pillow case and easier for the child to use since the sensors do not need to be carefully positioned within the underwear. Pull-ups cannot be used because the wetting must be allowed to touch the pad. The pad sensor can be messier, but it is less cumbersome for the child. The pad and alarm system is usually more durable and louder than other alarms.

There are several other factors to consider when purchasing a particular alarm device. These factors include:

- Batteries
- Warranty
- Durability

- Loudness/Tone
- Options (light, vibration, color)
- Weight of alarm (especially if attached to pajamas)
- Comfort of pad/sensor
- Difficulty of positioning sensors in undergarments
- Cost
- Wireless vs. wired

The Ideal Bedwetting Alarm
1. **Loud**
2. **Wireless**
3. **Inexpensive**
4. **Durable**
5. **Reliable**

BATTERIES

Battery type is important for some people. Alarms usually are powered by 9 volt, AAA, AA and watch batteries. Some of the pad and alarm systems plug into the wall electricity. The batteries are usually located in a small beeper-sized case in the traditional systems that is either connected to the pajama top or placed near the pillow or bedside. Usually no correlation exists between the battery type and the loudness of the alarm.

WARRANTY

If a warranty is offered, it usually only covers manufacturer defects for the first 30 days. Some manufacturers will provide a one-year warranty. The warranties cover the function of the bed alarm system, but do not usually

guarantee the alarm will correct the bedwetting problem. Children can be very rough with the alarms and warranties do not usually cover normal wear and tear.

DURABILITY

It is difficult to determine the durability of a bedwetting alarm prior to purchase. It is wise to ask others that have purchased an alarm system to see if they think the device is durable and functional. Many of the alarms contain fragile electronics and they are usually good for a few months use. Children can break these devices by pulling the wires, throwing them, stepping on them, etc.

LOUDNESS/TONE

Most manufacturers and distributors will claim their alarm is loud and will wake your child during sleep. The loudest or most annoying tones are the most effective in waking a child, but most alarms are not capable of waking a deep sleeping child quickly enough to use the restroom before the wetting occurs. It is important to try to get the loudest system available. Some alarms come with various tones and volume options, which may be useful since different tones and sounds may be more effective in waking you or your child. The bedwetting alarm should be effective as long as someone who can then awaken the child hears the alarm.

OPTIONS (LIGHT, VIBRATION, COLOR)

Although nice, these options do not usually influence the effectiveness of the system. Some alarms will come with a flashing light or a vibration device in addition to a sounding alarm. Since most children do not wake to a flashing light or a vibration, these options are not needed under normal circumstances. However, children that are deaf may benefit from these options. If the child who bed wets is concerned that others may hear an alarm, the light or vibration systems may be helpful, but again, children do not usually wake to these stimuli. It is important for you and your child to choose a device that is most suitable for your situation. An alarm with many features is more likely to experience malfunctions. It is best for your child to feel a sense of ownership and participation when choosing an alarm system.

WEIGHT

If you choose an alarm that is attached to the pajama tops, then weight may be an important consideration. A bulky or heavy alarm may be uncomfortable. Usually the alarms that use AAA and 9-volt batteries are the heaviest. Wireless alarms avoid having anything connected to the shirt or pajama top.

COMFORT OF PAD

If a mattress pad and alarm system is chosen, then the pad material should be comfortable to sleep on. Rigid or rough surfaces will discourage your child from wanting to use it. Plastic can be sticky or cold to sleep on. Ideally, the pad should be soft and can be placed on top of the sheet for optimum comfort and use. The best way to make a pad sensor comfortable is to place it in a pillowcase and then position it on top of the mattress sheet (preferably a waterproof sheet or pad).

POSITIONING SENSORS IN UNDERGARMENTS

Alarms have different sensors that need to be placed in the undergarments. These sensors need to come in direct contact with the urine as soon as wetting occurs. There are many different ways to position these sensors. Listed below are some of the various methods for positioning sensors:

Snaps to underwear- the manufacturer recommends wearing two pairs of underwear to avoid direct contact between the skin and the snap and sensor. The underwear needs to be thin for the snaps to work, and sensors cannot be snapped to diapers or pull-ups.

Clips to underwear-this type of device can pinch, and its contact point is small and must be positioned carefully. The clip is somewhat cumbersome, bulky, and difficult to use with pull-ups and diapers, especially when connected to a wire.

Sewn patch to the underwear- this device requires sewing either the sensor or a Velcro patch in the undergarment. Unless several sensors are purchased, a limited number of undergarments can be used. This sensor will stay in place and can be positioned exactly where you want.

Strips or pads that are placed in the underwear-these devices can be used with any type of undergarment including disposable underwear, or pull-ups. Unless there is a pouch in the undergarment, the pad can slip out

and not be in direct contact with the urine. These sensors are usually durable, but the strips or pads can be uncomfortable when placed between the legs.

Wrapping sensors in toilet paper or placing in a feminine pad-if the sensor is wireless then it can be wrapped in toilet paper or placed in a small cut feminine pad and positioned in the underwear. This will avoid sensor movement and soften the feel. The wet toilet tissue or feminine pads are also easily discarded.

Pad and alarm system-these devices require the child to sleep on the pad that contains the large urine sensor. Careful positioning of the pad is required to get the best contact. The child can move the pad either intentionally or by accidental movement during sleep. Securing the pad is sometimes needed to avoid this problem. This can be done with safety pins or careful positioning. The pads are usually very durable.

Wearing two pairs of underwear-is a great trick to position sensors and soften the feel of the sensors.

COSTS

Costs can vary significantly among the various alarm systems. Prices range from $20-$500. Most alarm systems that use the undergarment sensor and a shoulder alarm device range from $50-$150. The best alarms are wireless and they are usually more expensive ($65-$250). Mattress pad and alarm systems are slightly more expensive. It is best to get the alarm you want to work with and not necessarily the cheapest or the most expensive.

Reputable
Bedwetting Alarm Manufacturers

- PottyMD
- Palco Labs
- Koregan
- Malem
- DRI-Sleeper
- Star Labs

Chapter 10

CHOOSING A MEDICATION

You and your child's doctor will determine which bedwetting medication is best for your child. As a "team", you and your child's doctor should discuss the pros and cons of the various medications being considered. Success rates should be realistically considered prior to using a medication. Not all bedwetting should be treated with medications, and more conservative treatments may be preferred. There may be a "placebo effect" (even a sugar pill would work) when taking medications for bedwetting. Be prepared for relapses, which are especially common with desmopressin. Beware of homeopathic or herbal medications that make claims to cure bedwetting. Do your homework before giving your child an herb, vitamin, or medication that is not proven to be safe.

Side effects are rare and usually not life threatening. More caution is advised when using imipramine, but with the appropriate instruction and precautions, it is a safe option. Generics are available for oxybutynin and imipramine. Desmopressin is not yet available as a generic in the United States. If you should have any questions about your child's medication ask your doctor or a pharmacist.

Oxybutynin's actions are quick, and if the bedwetting does not improve quickly while taking this medication then it should be stopped after a few weeks. Opinion differs on how long one should take imipramine or desmopressin. If the bedwetting is not significantly better (twice as many dry nights) within a month, the medication should be stopped or the dose slightly increased. Since the medications all have different methods of correcting the bedwetting, if one does not work, then another can be tried. Most pediatric urologists do not recommend using a combination of these drugs together. Remember there is not a "magic pill" for bedwetting, and you should be prepared to try alternate treatments if the bedwetting continues to be a problem.

Chapter 11

COPING TIPS FOR PARENTS

The best advice I have for parents of children who wet the bed is to first get reassurance from your child's pediatrician or family doctor that there is nothing medically wrong with your child. Since bedwetting is rarely associated with any significant medical conditions, you will most likely be reassured when your child's doctor tells you nothing is medically wrong. Next, you should feel free to discuss your child's situation with others so that you will not feel alone and you can get some much-needed support. You will probably be amazed by how many of your friends and family members have also been through a similar situation. Be careful not to discuss the problem with others while your child is around in order to avoid any embarrassment. Remind those you are talking to not to tell other children and their friends. Children can be cruel, and your child may become vulnerable to other children's ridicule. You may need to walk a fine line (talk a fine line) between having the openness to discuss the problem with others so that you can get a better understanding without violating your child's privacy.

Once your child's physician has reassured you that there is not a medical problem causing the bedwetting you should start to establish an environment that is best suited to deal with the problem. Consider informing others that will be taking care of your child about the bedwetting situation. This may include grandparents, teachers, day care workers, and babysitters. Tell them what you are doing to help your child, so that they can be supportive of your treatment approach and supportive to your child. Inform sisters and brothers that bedwetting is not to be made fun of, and that they also need to help. Family discussions are sometimes needed to express the importance of not embarrassing and punishing the child who bed wets.

BEDDING

Set up the child's bedding so that it is easier to wash. This will make it less difficult for you and your child to maintain a dry and clean place to sleep. Make sure you have spare or backup sheets available at all times so cleaning in the middle of the night is not necessary. Try to make the cleaning process as simple as possible. Odor and wetness should be avoided so that both the parents and child do not become frustrated. Too much work (especially in the middle of the night) will only lead to more tension and an unpleasant situation that will not allow for quick improvement. There are several products that make cleaning easier and improve wetness and odor problems. Some of the bedding products are listed below and they can be obtained from many different websites and department stores.

Waterproof mattress covers-these will protect the mattress from stains and urine odor. Mattress covers are not very easy to change, but they will protect the mattress and avoid long-term odors and stains. Waterproof mattress covers can be padded with absorbent material that will keep the child drier. Plastic sheets are less expensive, but they are also less comfortable to sleep on. Most pads are easily washed and come fitted to most mattress sizes. If your child wets often or wets large amounts then waterproof mattress covers should be considered.

Waterproof mattress pads-these come as both disposable and reusable pads. They are usually placed on top of the sheet so that the urine does not reach the sheet. These can be thrown away (disposable) or aired/washed (reusable) without changing the sheets. Make sure you get a pad that will not slide or wrinkle and that it is carefully positioned under your child so that the urine is absorbed. Some have wings that can be tucked under the mattress to avoid movement.

Inexpensive mattress-foam and other less expensive mattresses can be purchased so that you do not feel like your child is "ruining" a good mattress. Mattresses can be very expensive. If an inexpensive mattress is used your child will not experience guilt about "ruining" a good mattress. Once the bedwetting stops then these inexpensive mattresses can be exchanged for more quality ones.

Easy care sheets-knitted or breathable cotton or cotton/polyester blend sheets that do not require ironing or special care should be used. Ideally these sheets should not be expensive and you should have several on hand so you are not made to do laundry immediately or in the middle of the night. It is very important to make sure your child is comfortable with his bed and sheets. He should like his bed and want to sleep there. Children are more likely to want to sleep in their beds if the sheets have a child theme, and if the bed is comfortable. Kids are more likely to help with the bedding care and avoid soiling, if they are proud of the bedding. Children should choose their own sheets and pillowcases, whenever possible, so they can feel a sense of pride and ownership of their bed.

Most people believe that children who wet at night should participate in their own bed care. If your child is young it is unrealistic to expect changing and cleaning the sheets. Even older children should not be expected to do all of the work since it will come across as a form of punishment. Under no circumstances should your child be forced to do all or most of the laundry as a form of punishment. Remember it is not her fault. It is however, important for your child to participate in some of the bed care. She should be aware of what is required to keep a clean and dry bed so that you can continue to have open discussions about the problem. Although it has not been proven, many therapists believe that simply helping with the laundry and changing the sheets may help the subconscious control that one may have over correcting the problem. Your child may even feel less guilt by being helpful, and the parent may have less resentment by not having the entire responsibility of maintaining a dry and clean bed. It is also a good idea to have all of the care providers help with the cleaning tasks since this will foster a "team" approach. If one parent feels like she is doing all of the work then resentment may set in. If resentment develops then it must be addressed in order to avoid further problems. A team approach is extremely helpful.

Children like to sleep with their parents. They commonly try to negotiate there way into your bed especially if theirs is wet. This should be discouraged. If a child has a bed that is easy to get in and out of and it remains dry and clean, then they are more likely to stay there. This means the child's bedroom, bed, and access to the restroom should be easy to navigate. This will make it easier for your child to use the restroom when he has an urge. Easy access to the restroom is important. Make sure the bathroom door opens easily, the lights are easy to turn on and the toilet is friendly to use. Nightmares and traumatic sleeping arrangements can aggravate a bedwetting problem. Allow your child to wake you if he wishes to gain a sense of comfort or if he needs help using the restroom or cleaning up after an accident has occurred.

CLOTHING

The clothes your child wears to bed should be comfortable and easy to put on and take off. Pajamas with many buttons are difficult to change if they become wet. Two-piece pajamas are easier to keep dry with less work. Usually only the bottoms are wet and will need to be changed. If you are lucky enough to get the child to the restroom quickly and in time to

use the potty, then the pants and undergarment should be easier to remove in time. Several clean PJs should be available at all times so that you are not forced to make do with other clothes or have your child be without clean replacement pajamas. If changing clothes in the middle of the night becomes too difficult then both you and your child will be agitated. You should be prepared to make this part of the process be as easy as possible.

DIAPERS AND PULL-UPS

Pull-ups and diapers are controversial when discussing treatment of bedwetting in children. It is easier to simply put on absorbent disposable diapers or pull-ups at nighttime. Some believe if the child is young, less than 5-6 years of age, then bedwetting is not a significant problem, and it is acceptable to use disposables diapers or pull-ups to avoid wet beds while working through bedwetting issues. If the child is older, it is more difficult to find pull-ups that fit properly. Even as larger pull-ups are becoming available, older children are less willing to wear them because they feel "like a baby." If a child does not want to wear pull-ups and they are willing to help with their clothing and bedding care, then pull-ups and diapers should be avoided. The diaper industry is promoting larger diapers, pull-ups, and disposable briefs for older children with bedwetting and other potty habit problems. Their goal is to sell diapers, not correct the problem. These items may be helpful in some potentially embarrassing situations, but they are not generally considered to be beneficial in those trying to overcome the bedwetting problem.

In general, if a child and parent are motivated to correct the wetting at night, then disposables should not be used even in the younger children. If the child has just recently potty trained, then diapers and pull-ups can be used without much hesitation. Children who have been potty trained for more than one year should not be forced to use diapers or pull-ups if they do not want to. If a child really wants to wear pull-ups then they should be temporarily allowed. However, avoidance of diapers and pull-ups will most likely allow for a quicker resolution of the bedwetting. This of course will require more laundry and care. If planned carefully the work and frustrations can be minimized.

The reason bedwetting seems to stop earlier in children without pull-ups is not completely understood. Clothes that are wet will more likely wake a sleeping child than will a full diaper. The sensation of being wet is not usually comfortable. Waking in the middle of the night to change wet clothes might "teach" or "condition" a child to wake on their own prior to wetting. Parents that are waking to change clothes and bedding are more likely to stay focused and motivated on treating the bedwetting problem. Parents that usually rely on diapers and pull-ups are more likely to "wait" for the child to outgrow the problem. Children that desire to stay out of diapers are also more likely to work with their parents in all other aspects of bedwetting care and prevention.

It is up to you to decide which approach is best for you and your child. Certain situations may force you to use pull-ups or diapers (sleeping in other people's beds, sleepovers, etc.) on a temporary basis. Whatever you choose to do is acceptable, but remember your child will not want to stay in pull-ups for long. Just because bigger pull-ups are now available does not mean they are the best option for treating your child's bedwetting problem.

Chapter 12

ABNORMAL DAYTIME POTTY HABITS CAN CAUSE BEDWETTING

I have tried virtually everything that is currently available for correcting bedwetting in my patients. None of the treatments has been more successful than what I am about to propose, especially for those with difficult to treat bedwetting problems. In the past, doctors and parents have mistakenly assumed that since bedwetting is a problem that only occurs at night, it must be a problem with something that happens at night or during sleep. This is why physicians have focused on sleep habits and nighttime urine production. My theory is that bedwetting (in many children) is a problem that develops during the day, but comes out at night. In other words, I believe that abnormal bathroom habits during the day can be a major cause of wetting at night. Before I attempt to sell you on this new concept, let us first explore "normal potty habits" so you can better understand how abnormal daytime bathroom habits affect bedwetting.

> **"My theory is that bedwetting (in many children) is a problem that develops during the day, but comes out at night."**

UNDERSTANDING NORMAL POTTY HABITS

Newborns have reflex emptying of their bladder and bowel. In other words, when the bladder or rectum fills up, it is quickly emptied. It is a spastic or reflex emptying, and requires little cognitive thought (brain power). That is why babies have frequent wet and full diapers. Their diet of formula and breast milk also contributes significantly to frequent bowel movements. As the infant becomes a toddler, their diet changes, and their bowel movements become more bulky. They are also beginning to

understand their bodily functions and start to experiment with holding their urine and stool. Natural growth and holding both urine and stool will result in less frequent wet and dirty diapers. The bladder may stretch some, but holding will stretch the large intestine (colon). As a result, the capacity to hold more is increased, and their intervals between emptying their bladder and bowel become longer.

Toddlers may avoid urinating or having a bowel movement, so that they do not have to have their diapers changed (young children are probably smarter than we realize). Diaper rashes may become painful, especially when they come in contact with urine and stool. For this reason, diaper rashes may also cause a child to hold his urine or stool longer. Psychologists tend to believe that toddlers hold their urine and stool due to control issues since these are two of the very few things they can control. There are probably some valid psychological explanations for why some children have control issues and hold their urine and stool, but it is not practical to explore these issues in this bedwetting book. Quite frankly, regardless of any psychological explanations, if a toddler develops problems from abnormal potty habits (namely stool holding) they will need to be corrected. Awareness that a child less than two years of age possesses the ability to experiment with holding urine and bowel for extended periods of time, can help parents better understand how holding issues can transfer into the post-potty training era.

Once children experiment with potty training, they learn several processes that should lead to establishing normal bladder and bowel functions. In order to store urine, the bladder relaxes much like a balloon and holds relatively large volumes of urine under low pressure. Bladder pressure does not start to increase significantly until the bladder gets near capacity. While the bladder is storing urine, the sphincter muscles that wrap around the urethra are tight so that urine does not leak. There are two sphincter muscles, one that a child cannot tighten or control, and one that can be tightened and controlled. When one tightens the pelvic or bottom muscles she is contracting one of these sphincters. When the bladder gets full, there is the urge to urinate. By contracting one of the

sphincters the urge can be suppressed which allows enough time to get to the restroom. When going potty, one relaxes the tightened sphincter muscles and the bladder muscle contracts, and empties. Bowel movements are similar but they sometimes require straining to move the stool into the rectal area, which then requires some relaxation and dilation of the anus allowing the flow of stool. The pelvic muscles that control the sphincter must be relaxed to effectively empty both urine and stool. When done using the potty, intermittently contracting and relaxing the pelvic and sphincter muscles the bladder and lower bowel then empty any residual urine or stool. When completely finished using the bathroom, the pelvic muscles and sphincters will reestablish the tone that is required to once again store urine and stool.

This normal process is a very effective way to empty and store urine and stool. The most effective urination may occur when having a bowel move-ment—we pee and poop, and then pee and poop again until empty. In summary, as the bladder stores urine, the sphincter muscles remain tight. When beginning to urinate, the pelvic muscles relax and the bladder contracts to push the urine out. This process is similar for a bowel movement (see illustrations).

BLADDER STORING URINE

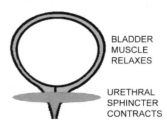

BLADDER MUSCLE RELAXES

URETHRAL SPHINCTER CONTRACTS

NORMAL BLADDER EMPTYING

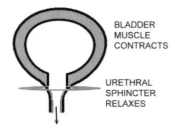

BLADDER MUSCLE CONTRACTS

URETHRAL SPHINCTER RELAXES

BOWEL STORING STOOL

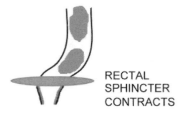

RECTAL SPHINCTER CONTRACTS

NORMAL STOOL EMPTYING

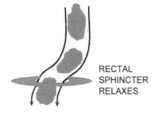

RECTAL SPHINCTER RELAXES

Just as some individuals are born with big feet or long arms, some children are born with large bladders and bowels. The size of the bladder or colon can be a physical variant that affects what problems a child may or may not have with potty habits. A child that is born with a larger bladder or colon does not necessarily mean that it was stretched or that it is abnormal. Studies have shown that children with bigger bladders have fewer problems with bedwetting and urinary frequency. However, a large bladder may be harder for a child to empty or it may allow the child to avoid using the restroom for longer periods of time. If the colon, or large intestine, is big then less frequent bowel movements or mild constipation may occur. The differences in bladder or bowel size are usually not significant form one child to another, but one must take this into account when trying to explain why children experience different types of potty problems.

In order to avoid confusion among those trying to help a child with potty problems, an understanding of normal bladder and bowel functions is extremely helpful. For example, we will commonly treat children that have only urinary symptoms with a bowel program. We currently do not have any medicines or surgeries that will make a child urinate well and completely empty the bladder. But if we give them a mild laxative and an aggressive bowel program we turn them into "super poopers." A child who is having frequent bowel movements will go to the restroom more often, sit longer on the commode, and empty his bladder better. By virtue of controlling and regulating children's bowel movements, we regulate the processes by which they work with their pelvic muscles and relax and empty.

> *Super-poopers=Super-peeers*

UNDERSTANDING ABNORMAL POTTY HABITS

Please take a moment to answer the questions below, to determine if your child's daytime potty habits are as good as they should be. Your answers should be as honest and accurate as possible.

Has your child ever experienced any of the following?
- Difficulty potty training
- Never completely potty trained
- History of constipation
- Urinates frequently (frequency)
- Does not urinate often (holding)
- Avoids using the restroom (wiggles, squats, dances)
- Avoids restroom during certain activities (TV, playing, etc.)
- Needs to urinate quickly (urgency)
- Difficulty starting urine stream (hesitancy)
- Strains or pushes to urinate
- Urinates in a hurry (pit stop)
- Does not urinate first thing in the morning
- Have daytime accidents (incontinence)
- Cannot get to the restroom quickly enough
- Leaks with laughing, coughing, etc.
- Dribbles after urinating
- Has never had a dry day (daytime)
- Have hard, large, or painful stools
- Have bowel accidents (encopresis)
- Holds bowel movements
- Has accidents (urine or stool) that occur at certain times or places
- History of blood in the urine
- Has belly pain at belly button or below
- Stains underwear—pee or poop
- History of urinary tract infections

If you answered yes to any of these, your child may have a problem with daytime potty habits that are contributing to their bedwetting problem. If you answered yes to several of these questions, then your child most likely

has significant daytime urine and bowel problems that should be addressed in order to help with the nighttime wetting.

Abnormal daytime potty habits medically referred to as "dysfunctional elimination syndrome", presents at all ages and in a wide variety of ways. Early after potty training, it is very common for children to feel like they need to use the restroom frequently. Urinary frequency is the most common urinary complaint in children three to four years of age. These children may also have intermittent episodes of not using the restroom for long periods of time, as well as episodes of urgency and frequency. Children with these problems not only use the restroom often, they also go in a hurry. Episodes of urgency and frequency can be very frustrating to parents. Urinary accidents, day or night, are also directly related to abnormal potty habits. Daytime accidents are commonly due to a child holding for so long that she eventually cannot get to the restroom quickly enough. Daytime incontinence can occur without any apparent notice, warning, or sensation to void. In other words, your child may have held her urine without even being aware. Abdominal pains, urinary tract infections, constipation, blood in the urine, and genital discomforts are also very common symptoms of children that have not "learned to stop and to go". We will discuss each of these common toileting problems.

ABNORMAL BLADDER EMPTYING

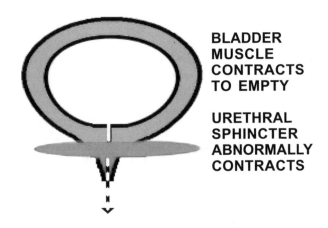

BLADDER MUSCLE CONTRACTS TO EMPTY

URETHRAL SPHINCTER ABNORMALLY CONTRACTS

URINARY FREQUENCY

Problems with urinary frequency are usually intermittent, and occur more commonly during times of excitement and distress. Some refer to urinary frequency as having a "nervous bladder" or an "overactive bladder." Frequency is most likely to occur in children who are not willing to relax, take their time and completely empty their bladder. As a race fan, I commonly refer to these bathroom visits as "pit stops." Children are excited about other activities such as playing, reading, socializing, watching TV, or playing computer games, that they try to hold their urine as long as possible by tightening their pelvic muscles and sphincters. They will commonly wiggle, dance and squat to avoid using the restroom. When they finally go, it is usually urgent, and they do not take their time to relax and let all of the urine out. Their bladder may feel empty, but it is not.

If a child is distracted and unable to relax their sphincter muscles, they may only void small amounts of urine and leave a significant amount behind. The best way to convince a parent that their child is not emptying completely is to perform a bladder ultrasound after the child has urinated. Bladder ultrasounds are commonly performed in pediatric urologists' offices. A child is instructed to use the restroom and empty. An ultrasound picture of the bladder will then show if there is significant urine left behind. A bladder that is not completely empty takes less time to fill up

again and will need to be emptied more often. Therefore, urinary frequency is very easily explained in children with abnormal potty habits. My daughter suffered from intermittent episodes of severe urinary frequency. It was not until I made her relax and take extra time in the restroom that I started to see significant improvements. On several occasions she told me that after staying on the toilet longer, more urine came out and it surprised her. I, of course, praised her since this meant she was probably empty.

Children with urinary frequency and other voiding problems should not be encouraged to drink large amounts. This will only cause the child to make more urine, but it will not promote better bladder emptying. Consuming extra liquids may cause a child to be more resistant to use the restroom since they already go to the restroom so often. Drinks that contain carbonation, caffeine, or sugar are thought to be irritating to the lining of the bladder and may cause a child to urinate frequently. Caffeine and sugars are body stimulants and give children extra energy that will also prevent them from relaxing on the toilet when they need to. However, in my opinion, urinary frequency is most commonly caused by incomplete bladder emptying and not by certain types of drinks.

Medications to relax an "overactive bladder" and decrease urinary frequency do exist and are commonly prescribed in adults. These medications are effective in some children, but the underlying abnormal potty habits must be addressed. These drugs have a common side effect of causing constipation. Constipation, as stated earlier, must be avoided when attempting to establish good potty habits. The most common medications used are oxybutynin (Ditropan, Oxytrol), tolterodine (Detrol), and hyoscyamine (Levsin). Hopefully, you will elect to work on your child's potty habits prior to using any of these medications.

URINARY URGENCY
Urinary urgency is also extremely common in children of all ages. This problem usually becomes very obvious to others when a child squirms, squats, wiggles, and demands quick access to the bathroom.

Having to urinate urgently can happen at inopportune times; when you are in the car, shopping, or in the middle of some other activity in which quick access to a restroom is not always available. In the past, parents were encouraged to tell their children to hold in the urine and avoid frequent use of the restroom. It was thought that this would stretch the bladder, and would give them more time before needing to use the restroom. Recently, pediatric urologists have discouraged the practice of having children try to avoid using the restroom. Having a child postpone using the restroom forces them to tighten their pelvic muscles, thereby strengthening these muscles. Then, when the child wants to go to the bathroom, he is less likely to be able to relax the strengthened pelvic muscles and let all of the urine out. Furthermore, tightening these pelvic muscles when the bladder is full is only going to cause the bladder to have spasms and contractions. The bladder is a muscle, and if it attempts to empty against a tight sphincter it will thicken and become stronger. As a result, it will be more forceful and quick with its attempt to empty—thereby causing urgency. A thickened bladder may become normal and thinner once a routine is established, and it no longer needs to fight against a tightened sphincter muscle. When children experience urinary urgency they have usually waited too long and should have used the restroom earlier prior to it becoming an emergency.

Younger children do not understand the importance of urinating often and taking their time on the potty. Many children, especially those who have just been potty trained, do not realize their bladder is full until it is extremely full or too late. Requesting or demanding a child to use the potty often will alleviate the episodes of urgency. It is very important to constantly remind your child to use the restroom. I instruct parents to recruit as much help as possible from grandparents, babysitters, teachers

and other care providers in getting their child to use the restroom. Children should use the restroom at least every two hours. The medications that relax the bladder and avoid spasms in adults can also be used in children with urinary urgency. These medications may give the child more of a gradual warning prior to the sudden urge to urinate. These medications are also commonly used in adults with urinary incontinence and frequency. The most commonly used drugs are oxybutynin (Ditropan, Oxytrol), tolterodine (Detrol), and hyoscyamine (Levsin). The problem of holding the urine until the last moment, and the thickening of the bladder will not be corrected with these medications alone. Only restructuring the child's daily potty habits will correct the root of the problem. In children with severe urgency, these medications may be helpful when used in combination with treatment of potty habit problems. If these medications are used, they should only be prescribed for a short period of time, until the potty habits begin to improve.

DIFFICULTY GOING POTTY

Children with abnormal potty habits can experience episodes of being unable to start a urinary stream or have a bowel movement. Feeling the urge, but being unable to void can be extremely frustrating for children. The ability to pee on command is not always an easy task. Children who are intent on holding urine during the school day or during fun activities are exercising their pelvic muscles. This holding makes it more difficult to relax these muscles when attempting to pee. Children who are unable to urinate easily will commonly give up quickly and return at a later time. They should be discouraged from giving up and should be instructed to sit down, whether boy or girl, with their bottom deep into the toilet seat and their legs spread apart and relax. If this does not work, closing their eyes and taking deep breaths may help. Children with this problem should remain on the commode for several minutes in a relaxing position (younger kids should use a step stool to relax their feet and legs).

Kids should be discouraged from taking games, books and toys into the restroom since this will only further distract them from understanding their normal bodily functions. Parents are commonly guilty (I have done this myself) of standing there in the bathroom coaching their child while running the water and requesting they urinate. These coaching episodes are also

70

distractions and should be avoided unless the children are young. Placing the child in the restroom by themselves, instructing them to relax (do not strain, do not grunt, do not push), and telling them you will return in a few minutes is the best way to teach them how to relax and empty. Most times children will sit long enough and will learn to relax their pelvic muscles enough to let the urine out.

Difficulty in having a bowel movement is no different. Children will state that they need to have a bowel movement, but then come out of the restroom and say they could not go. If the pressure or sensation to go passes, a child will get up and avoid going until a later time. This may lead to constipation and more difficulty going the next time. Avoidance of constipation with mild laxatives, a bowel program, and a good diet will also help alleviate this problem.

PEE AND POOP HOLDERS

Children that use the restroom infrequently without having accidents probably have larger bladders and colons. These infrequent visits to the restroom may eventually cause significant problems in these children. They may develop abdominal pain because their bladder or bowels are extremely full. If they do not urinate often, they may develop urinary tract infections and incontinence. If they do not have regular bowel movements, they may stretch their colon and develop constipation. Eventually poop accidents (encopresis) may occur.

Children that do not use the restroom often may develop belly pain that causes the parents to seek medical advice. This in turn may cause the child to undergo unnecessary testing, x-rays and procedures in order to determine the cause for the abdominal pain. Usually the child is simply not urinating

often enough or she has constipation—both of which can be easily treated with correcting daytime potty habits.

URINARY TRACT INFECTIONS

If a child does not frequently empty the bladder, a urinary tract infection may develop. Abnormal potty habits are the most common cause of urinary tract infections in children. Girls are more prone to infections than boys, because they have a shorter urethra that is close to the rectum. This configuration allows bacteria to more easily enter the bladder and vagina. Bladder infections (cystitis) usually present with burning, frequency, urgency, and incontinence. Bladder infections are problematic, but they do not usually cause significant damage to the kidneys or bladder. Kidney infections (pyelonephritis), on the other hand, usually present with fever, back pain, nausea, and fatigue. Infections in the kidney can cause severe damage and scarring. Urinary tract infections warrant an evaluation and treatment by a physician. Kidney and bladder tests and x-rays are usually performed in children with urinary tract infections. Abnormalities or birth defects of the bladder, ureter (kidney tube), or kidney may be discovered, including vesicoureteral reflux.

CONSTIPATION

When asked, parents are not always aware of their child's bowel movements. Once a child starts to wipe her own bottom, the parents are less likely to know if constipation exists. Unless a child complains of difficulty or has painful bowel movements parents may not be involved with the process. Because diet and viral illnesses can cause loose stools, fluctuations in bowel movements will occur, and constipation may go unnoticed. On average, children should have a bowel movement every day. Anything less than this could be considered constipation. Some children, because their colons are larger than others, may not go as often. However, if the bowel movements are large, hard, or painful then constipation is probable.

Diet contributes to the development and avoidance of constipation. A diet of fruits, vegetables, fiber, and increased fluids is helpful in avoiding constipation. An improved diet can be very helpful in preventing recurrent constipation, but it is usually not enough to correct significant constipation. Simply changing the diet and instructing the child to use the restroom is not always enough to correct significant constipation and its associated problems.

There are some rare abnormalities of the colon, rectum, and neurological system that cause constipation and bowel accidents, and for these reasons consultation from a physician may be necessary. Children who develop belly pain and constipation may undergo testing, x-rays, and procedures to see if anything is medically wrong. Further testing, including a colonoscopy (placing a scope within the colon to look for abnormalities) may be performed by a pediatric intestine specialist (gastroenterologist). If a child is unable to have a bowel movement he may require hospitalization in order to aggressively clean out the colon with enemas, suppositories, or medications. Since most constipation in children is caused by abnormal potty habits (holding) and diet, these tests and procedures may not be necessary. Abnormal potty habits and diet are things that you as the parent can work on at home.

Kids with constipation will need to use the restroom often, and they will need to relax and take their time. Children must have good pee habits to have good poop habits. However, just improving the potty habits may not be enough to correct the constipation. Many children also need an aggressive bowel program to keep their stools soft. Usually a mild laxative is required for several weeks or months. There are many excellent laxatives that, if used carefully, will give excellent results. These include milk of magnesia, mineral oil, Senokot, lactulose, and Miralax (glycolax). Finding a laxative your child likes may not be easy, and parents should be prepared to make sure that their child takes it regardless of the taste. Laxatives that make the stools softer and more regular are not usually enough to shrink the colon and instill good potty habits. A goal of two bowel movements a day is recommended. It is important to adjust the laxative according to the poops. Do not focus on a specific dose, rather slowly increase and decrease the laxative amount to the desired effect. Diarrhea and weight loss are signs of excessive laxative use, and any of these symptoms should be brought to the attention of your child's doctor. Several months of a low-dose laxative use results in only 2-3 soft mushy bowel movements a day is usually not harmful. Low dose laxative use is probably required to instill a pattern of regular bowel movements and help develop good potty habits. Remember, super-poopers are super-peeers!

BLOOD IN THE URINE

Straining to pee, stretching the bladder and forceful urination can cause irritations to the bladder and urethral linings and cause blood in the urine. Irritations around the urethral opening that are caused by excessive wiping, urinary leakage, and rashes, can also cause blood cells to be seen in the urine test. These problems usually cause small amounts of blood to be present in the urine that is not seen with the naked eye (microscopic hematuria). The blood may go unnoticed unless a physician tests the urine. If a primary care physician discovers blood in the urine, then further testing and x-rays may be performed to rule out infection and other abnormalities. Frequent and complete emptying of the bladder, good local hygiene, and avoidance of irritation to the private parts can prevent blood in the urine and avoid potentially unnecessary medical treatment.

DAYTIME ACCIDENTS

Daytime urinary leakage (incontinence) is a frustrating and embarrassing problem for many children. Leaking of urine can start at an early age. Young children who experience daytime wetting usually will say they had absolutely no warning and no idea they were going to pee. Although these children do not intentionally lie, I believe they usually have some warning. In most cases, they waited too long before using the restroom and the bladder had a sudden urge to empty. Young children are often involved and focused on tasks, and ignore the subtle body messages that tell them their bladder is getting full. Warning signs include grabbing their privates, squirming and having to pee quickly.

Some children will contract their pelvic and sphincter muscles so they can delay a trip to the bathroom and continue to play or participate in their current activities. Eventually the muscles will no longer be able to hold the urine inside, and by the time they make it to the bathroom, it is too late. Young children do not often understand why they had an accident, and therefore do not learn from their mistakes. Instead, they tell themselves "the next time I will run faster to the restroom" or "I will hold my bottom muscles (sphincter) tighter next time." These responses further instill bad potty habits.

Urinary incontinence also occurs in older children. Adolescents and teenagers, especially girls, will complain of leaking when they giggle, laugh, or just after urinating. Giggle incontinence refers to episodes when the child wets with laughing, coughing, or activity. This is most likely a child's form of stress urinary incontinence that is commonly seen in older women. Laughing, coughing, and physical activity cause the abdominal muscles to tighten and place pressure on the bladder. If the bladder is usually kept full and the sphincter muscles temporarily relax, then wetting small amounts may occur. These children tend to be holders of their urine, which causes the bladder to thicken. A full and thickened bladder is more likely to contract or have spasms and cause leakage with laughing, coughing, or lifting heavy objects.

The best treatment for all children with daytime leakage is to instruct them to have frequent and relaxed bathroom habits. The child that describes a small amount of leakage just after using the restroom has not completely emptied her bladder. A "pit stop" or a non-relaxed bathroom visit is most likely the culprit. Diapers, pull-ups, and padded underwear should only be used for isolated situations. Parents and children should be encouraged to treat the problem, and not just hide the leakage.

Medications can be used to treat urinary accidents in children. These medications are intended to relax the bladder, and give children more of a warning to get to the restroom. These medications are the same that adults use for the "overactive bladder." Oxybutynin (Ditropan, Oxytrol), tolterodine (Detrol) and hyoscyamine (Levsin) are the most commonly used drugs for this purpose. These medications may be of some benefit since they do relax the bladder. However, they can have side effects that are problematic, namely constipation, and their routine use should be discouraged.

ABNORMAL DAYTIME POTTY HABITS AND BEDWETTING

My recommendation to parents with children that have any daytime potty habit problems along with bedwetting is that they seriously consider addressing the daytime issues first to see if this helps the nighttime wetting. Whenever I evaluate a child for bedwetting I usually ask the parents if

"there are any problems during the day." Initially they may deny any daytime problems. But with further questioning, many parents will offer information that points to daytime symptoms of going too often, hardly ever going, have to go in hurry, or having daytime accidents. Questions about how often their child uses the restroom during the day, how often they have bowel movements, and whether they take their time in the restroom are also important. Urinary tract infections, blood in the urine, and abdominal pain are also signs of abnormal daytime potty habits. Very rarely do I evaluate a child who bed wets and has absolutely no daytime potty habit problems or issues. Even in these rare cases, I am able to show the parents with the use of an office ultrasound machine that their child does not completely empty their bladder like they should.

Children who do not completely empty their bladder during the day probably do not empty their bladder prior to going to bed. If they go to bed with a partially full bladder they are more likely to wet. If the bladder is trying throughout the day to empty, and the child postpones going by holding, then the bladder becomes thicker and it is more likely to contract and empty at night. This is commonly referred to as a bladder spasm. Usually a child can hold urine during the day by squatting, wiggling and tightening their bottom muscles. At night the child is not able to squat and tighten their bottom muscles because they are sleeping and unaware of the bladder's need to empty. If a child has excellent daytime potty habits, his bladder is more likely to be completely empty when he urinates prior to going to bed. Children with good potty habits also have bladders that are less thick, less spastic, and less likely to contract at night.

In my experience as a Pediatric Urologist, I have found that daytime urine and stool patterns significantly influence a child's tendency to wet at night. Personality traits and lifestyles that lend themselves to abnormal daytime potty habits are also more likely to contribute to bedwetting. Current medical literature supports a strong correlation between constipation and daytime accidents and bedwetting. Yet most physicians have not yet recognized this connection. Pediatric urologists often care for children who have failed all other bedwetting treatments and still wet at night. Yet it is still not commonplace for them to recommend improving all of the daytime potty habits to see if the bedwetting stops. Even if the bedwetting

child does not have any obvious daytime problems, it is reasonable to make the child pee and poop regularly during the day to see if it helps the nighttime wetting.

My recommendation to parents with children that have any daytime potty habit problems along with bedwetting is that they seriously consider addressing the daytime issues first to see if this helps the nighttime wetting.

Chapter 13

DAYTIME PROGRAM FOR NIGHTTIME DRYNESS

If your child has any daytime bladder or bowel "issues" then the daytime program for nighttime dryness should be considered. Bedwetting alarms are excellent devices to overcome bedwetting, but if you child has significant pee or poop issues during the day the alarm is unlikely to help. Medications are reasonable treatments for bedwetting, but again, if your child does not have excellent daytime potty habits the drugs are not going to provide you with success. So here are my basic recommendations to make your child be the best peeer and pooper on the planet.

#1 Children should use the bathroom the moment they wake up and at least every 1½-2 hours during the day until they go to bed. This advice is confusing for parents with children who already go often. Children that go often also have episodes when they do not go frequently. These kids will hold it at times and will need to be told to use the potty. Avoid using statements like "wait till we get home" or "try to hold it longer." Do not ask your child if they need to go potty or if they can go. Just simply say it is time to go potty. With time, they will understand this request is non-negotiable. Give them a hug and tell them you love them, but tell them it is time to go potty.

#2 Children should be told to relax and take their time in the restroom. They must not strain, push or be in a hurry. Normal urination does not work with straining. Do not tell them to "push and get all of the pee out." If they are straining or trying too hard tell them to stop and relax. Close the bathroom door and tell them to sit (even the boys) deep into the potty with their legs apart. Younger kids should place their feet on a step stool. Closing their eyes and taking deep breaths is very helpful (I call this potty yoga). Do not send them with a book, game, or toy. This will only distract them from understanding the subtle sensations of normal emptying of their bladder and bowel. Pit stops are not allowed, and they should stay

on the potty for 3 minutes (they will think it is 3 hours but it is just 3 minutes). If they come out too soon, send them back. Just because they think they are done they should stay a little longer.

#3 Children with abnormal potty habits should avoid stimulants that cause them to be hyperactive and less likely to relax. This becomes especially important when a child has ADD, ADHD, or has a classic anal-retentive personality (type-A personality). They should also avoid drinks and foods that are potentially irritating to the bladder. There are many items one could list, but the biggest offenders are caffeine drinks, chocolates, and sugar/carbonated drinks.

#4 A bowel program is essential. Painful, difficult and long bowel movements will discourage a child from using the potty. Since the focus of our treatment is to encourage frequent bathroom visits, we do not want to be sabotaged by any bowel problems. Remember, even if a child does not have obvious constipation, they may need to have frequent bowel movements to urinate better. There are no medications or procedures that will make a child urinate better. But if they have frequent bowel movements (goal=2 mushy poops a day), they will have to sit, take their time, and usually pee well when they poop.

We can safely manipulate the bowel movements with diets and mild laxatives. Fiber, fruits, vegetables and increasing fluid intake can help with constipation. Good luck getting a child to take enough of these that will get the desired effect. Fiber is, however, becoming easier to give. Fiber now comes in wafers, cookies, and flavored drinks that are available at most pharmacies and health stores. The problem with fiber is that it requires increased fluid intake—which can be hard to achieve in a child. Laxatives are usually required to get the results that are needed. If the laxatives are given in low doses for several months that result in two poops a day they are not harmful. Making the stool softer and having a bowel movement a day is not usually sufficient to improve potty habits. Diarrhea and weight loss are signs that too much laxative is being used. If your child develops diarrhea, just decrease the dose, but do not stop it. You should start low (example ½-1 tablespoon a day of milk of magnesia), and slowly increase until 2 mushy stools a day is achieved. For older or larger children,

several tablespoons a day may be required. It will take a few weeks to determine the appropriate dose for your child. Parents should plan on their child taking the laxative for several weeks or months. There is no preferred laxative. Some taste better and are easier to give. Most laxatives do not require a prescription. Laxatives come in powders, liquids, pills, and chewables. Common examples include Miralax (glycolax), Senokot, lactulose, mineral oil, and milk of magnesia. Consult your child's doctor if you have any concerns or questions about laxative use!!

PROGRAM HELPERS

The basic program outlined above is usually sufficient to correct most potty problems in children. Many times additional help is needed from devices and products that assure your child will follow the program and achieve success. Listed below are some of the more common items one may want to consider when attempting to improve their child's potty habits.

Voiding and bowel diaries are useful when the parents are trying to monitor how often a child is peeing and pooping. Many times, the parents are not completely aware of what their child is doing while at school and away from home. By keeping a diary, one can see if a child tends to have more problems during specific times of the day, or at particular places or during certain activities. Diaries are only helpful if they are accurate and kept for several days. Comments about the amount of urine and the consistency of stool should be included. Simple homemade charts suffice, but specially designed diaries can be obtained. Diaries are also very important to track dry nights and keep everyone on track.

Reward systems are helpful especially for the younger children. As stated previously, praise from everyone is important. The child needs to know that good potty behavior is rewarded with praise and satisfaction. Stickers, small items, toys and even candy are commonly used (I am not a big fan of toys and candy since they

become bribes instead of rewards for good behavior). Calendars that allow several stickers to be displayed work very well and they promote consistent and daily feedback. Rewards should be simple and achievable. The rewards should also be directly related to good potty behavior and not linked to other issues or problems. The best rewards are those that require a "build up" and are not achieved with each successful event.

Bathroom timers can give children visual or audible feedback about how long they should stay in the restroom. Remember, children like to take pit stops and not take their time when using the restroom. Timers that have the children stay on the potty for about 3 minutes can be very valuable, since they will learn to take their time without the parents standing over them.

Alarm and Vibrating Watches are excellent tools to remind children during the day to go to the bathroom often. Depending on a child's schedule, they should be set to alarm or vibrate at least every 1½-2 hours. The watch should have a special feature that causes the watch to automatically alarm without resetting. Younger children may not mind an alarm, and teachers and parents who hear it can also instruct the child to go potty. Older children may be embarrassed by an alarm and desire a watch that vibrates. Vibrating watches are usually more expensive and larger than watches that sound an alarm. Either watch requires that the child respond to the reminder and not ignore it. Once again, these are excellent bathroom reminders!

Urine collection devices can be obtained from a medical supply company or a physician. These open containers fit into the commode and collect the urine. A child and parent can then measure and see how much urine is produced with each trip to the potty. If a small amount of urine is present, then the child is probably not completely emptying. By monitoring the amount, the parent and child team can work together to get more pee out each time the child uses the restroom. These collection devices provide positive visual feedback when the child is improving, while allowing the parent to monitor what is taking place.

Chapter 14

WHAT I WOULD DO IF MY CHILD HAD A BEDWETTING PROBLEM

As a family, we would first try to determine if the bedwetting was really a "problem" or if it was just something my wife and I wanted to correct. Once it was determined to be a problem for my child, then we as a team would aggressively approach the issue until we achieved completely dry nights every night. We would go into the bedwetting program with the desire to only back off and allow the status-quo wet nights to continue if the program and methods caused unreasonable tension and difficulties. We would discuss the problem and determine what we could do to overcome the problem. We would talk about bladder and bowel functions, along with all of the possible causes for why certain children wet at night. Our goal would be to educate ourselves, but more importantly, begin a friendly and comfortable dialogue about the problem so that our child felt comfortable discussing the problem. We would possibly arrange an appointment with our child's doctor or care provider to establish that there were no obvious medical problems. The pros and cons of the various common treatment options (namely bedwetting alarm, medication, and improving daytime bathroom habits) would be discussed.

If after this we still maintained a goal of complete and total dry nights, then I would encourage my child and family to pursue a step-wise approach. First, we would make the wet nights more "livable". We would obtain waterproof bedding that is easy to wash and keep clean. Our child would be made partially responsible for the wet sheets and bedding. He would be asked to remove the wet items and replace them with clean and dry ones. We would avoid pull-ups and we would make sure he had several easy-access clean PJs to wear. Laundry would not be made to be a big deal, but it would be addressed on a daily basis. Then we would initiate a daily record keeping system (like a calendar or diary) that we would constantly maintain for several weeks or months. The purpose of this record would be to keep us on task and to monitor success. This record would be

kept in a concealed place or we would use symbols that are not easily detected by "outsiders". In order to get the best results, we would make sure our child had the best possible daytime potty habits. In other words, we would not risk the possibility that our child was a holder during the day—even if it did not seem like he was holding. Our goal would be to make him the best peeer and pooper on the planet (sounds extreme but it works and it is harmless). He would use the restroom at least every two hours, he would sit to pee at home and at friendly/clean places, he would be told to relax on the toilet and avoid daytime stimulants-like caffeine and chocolate, and he would take a low dose laxative to make him poop twice a day. We would make our child realize that correcting the bedwetting sometimes requires that he have better bladder and bowel habits than other children. We would adhere to the "daytime program for nighttime dryness", even if it did not appear or seem that he had abnormal daytime bathroom habits. We would then also limit nighttime fluid intake by eliminating drinks 1-2 hours prior to bedtime.

We would strictly adhere to this program for several weeks to see if any progress was being made. The calendar or diary would show us how we were doing and if more dry nights had occurred. If we noticed that the daytime bathroom habits were not being adequately addressed, we would consider obtaining a watch for timed bathroom breaks (probably one that has an auto-reset function set to vibrate every 2 hours), and a home bathroom timer to avoid pit stops (2-3 minute bathroom breaks). My wife and I would be on poop patrol to make sure he was having 2 soft and mushy BMs a day. If not, we would improve the bowel program with fiber, fruits, vegetables, and increased laxative use. The school would be notified that our child needs to have increased access to the restroom and we would instruct babysitters, grandparents, and care providers that our child needs to use the restroom every 1½-2 hours. The school and others would not need to know why he needed to go often; they would just be instructed that this was a rule he needed to follow. We would remind ourselves that children with improved daytime bathroom habits are more likely to be dry at night.

If we worked diligently for several weeks on improving daytime potty habits and did not experience total dryness, then we would consider

ADDING another treatment option to the program. I would recommend that we obtain a bedwetting alarm (since I am not a big fan of medications) for nighttime use while we continued to make sure he had excellent daytime bladder and bowel habits. We would make my child aware of the various alarms that are available and how they work. He would have to understand that if we purchased an alarm he would have to wear it every night for several weeks or a few months. The only exceptions to using the alarm every night would be sleepovers and in places he would be embarrassed if it alarmed. We would have to determine if we wanted a sensor he would wear in the underwear or have a bed pad sensor he would sleep on. I would probably encourage him to get a sensor that would fit in the underwear since it is cheaper, easier to care for, and more likely to detect smaller accidents. A wireless alarm would be preferred since it would not require him to wear a complex contraption and it would more likely get him out of bed to turn off the alarm sound. We would remind him that he is responsible for remembering to use it, positioning the sensor, and setting the alarm. My wife and I would help remind him to use the alarm and confirm that it was operating normally. My son would understand that we would wake him up to use the restroom if the alarm did not wake him up. We would then monitor progress for the next several weeks, by continuing to record wet and dry nights.

Our family would try to maintain an up-beat and positive approach to the program at all times. Our child would be reminded that he will likely become dry if we stay with the program. He will always be supported by us, which may require that we remind him to go to the restroom, stay the course, and use the alarm. Even if he gets dry nights early on in the program, we would remind him that relapses are common and we should expect some problems along the way. If at anytime my family became unmotivated to continue, then we "the team" could stop. But we would have to realize that it will take longer for the nighttime wetting to stop.

It is very unlikely that all of this would not correct the bedwetting. But, if all of this did not correct the bedwetting then we would ADD the medication desmopressin (DDAVP®) to decrease nighttime urine production. This medication would be used as a last resort and the dose would be increased slowly if it did not seem to help. If the desmopressin

did not provide dry nights, not just less dry nights, then we would discontinue it after several weeks of use. We would then consider counseling to determine if any underlying psychological stressors are contributing to his bedwetting problem, altering his sleep patterns, or affecting his daytime bathroom habits. A visit to a pediatric urologist or pediatric nephrologist would be pursued if all else fails.

My Favorite Steps to Overcome Bedwetting:

1. Decide if it is a "problem"
2. Discuss the options for treatment
3. Build up dialogue and support within the family
4. Simplify bedding, PJs, and laundry tasks
5. Improve daytime bladder and bowel habits
6. Keep a diary or calendar for weeks/months
7. Limit nighttime fluid intake
8. Be patient for results/Monitor progress
9. Add a bedwetting alarm
10. Use the alarm every night for weeks
11. Track progress
12. Stay motivated and be patient for results
13. Possibly add a medication
14. Consider counseling if no improvement
15. Consult with a physician, or a specialist along the way

Chapter 15

LAST BIT OF ADVICE FOR PARENTS

Parents of children who wet at night must understand that they are not alone. Millions of children have the same problem. Your child is most likely not a bed wetter because of bad parenting or because of abnormal anatomy. By simply reading this book, you as a parent should gain a sense of relief and accomplishment because you are trying to help your child.

Before starting a treatment plan, please remember that your child does not intend to wet the bed and under no circumstances should she be scolded or punished for doing so. In only extremely rare circumstances do children purposely wets their beds. It should be assumed that your child is completely unaware of when she wet at night, unless she should awaken when it happens. Virtually all children desire to be dry at night, and any negative actions by others will only make the problem worse. Having said this, your child should understand that it is a problem that needs to be addressed and that she will need to help and comply with the treatment that you choose. Therefore, your child should participate in the decision making process if she is old enough to understand.

Because bedwetting is something children do not know how to correct themselves, they should not be embarrassed, shamed, or made to feel responsible for what they have done. You should do everything in your power to comfort and support your child during this difficult time. If you do not, the problem may only get worse. If you are frustrated, do not feel alone—millions of children wet at night. Always remind yourself that your child does not like a wet bed, and that he is completely helpless without your support. Do your best to hide your frustrations. Try to remind yourself the problem will go away with time and your help—it does not last forever.

Many parents and physicians do not focus on bedwetting until the child is older and it becomes a social issue. This approach may be okay, but if you feel that your child is going to have problems later you may want to tart

treating the problem now. Any treatment you choose will probably take time and require a commitment from you and your child. An active approach should be taken if there are any issues that cause you or your child any frustrations or concern.

Interesting Tidbit
It is estimated that 25% of parents and children drop out of their bedwetting treatment program—try to stay with it.

Since we do not know why children wet at night, we have not been very successful in curing or alleviating bedwetting. Like many other problems in medicine, bedwetting is a "medical" condition that may require a lifestyle change. Be prepared to make these changes and educate yourself about all of the possible causes of bedwetting, so you can tailor your treatment to achieve the best results. Beware of companies, products, and medications that boast of excellent cure rates. Most treatments realistically provide a 10-70% cure rate within a few weeks. As a general rule, 1/3 are cured, 1/3 wet less often, and 1/3 are no better, regardless of the treatment you choose. But if you are motivated, and if your child is motivated, then bedwetting can be cured in over 75% of children in just a few months. To get the best results, you and your child must be open-minded to consider all the possible treatment options. You may even need to try several different approaches at the same time.

Please remember that it is very common for children to have some abnormal potty habits during the day (dysfunctional elimination syndrome). If your child has ANY abnormal daytime urine or stool habits then she is less likely to overcome her bedwetting. It is true that most children do not develop significant bedwetting when they hold their urine and stool during the day, but others cannot become dry at night unless they have excellent bathroom habits during the day. I contend that children who desire to be dry at night need to have BETTER daytime potty habits than others. Parents should understand that if their child bed wets, they should try to make the child have the best daytime potty habits possible. If your child has excellent daytime bathroom habits then consider a bedwetting alarm, medication, or a combination of treatments. You and your child may also just sit back and be rest assured the bedwetting will not last forever.

Chapter 16

BEDWETTING RESOURCES

American Academy of Family Physicians
 Website: www.aafp.org
 Website: www.familydoctor.org

American Academy of Pediatrics
 Website: www.aap.org
 Book: Waking Up Dry

eMedicine
 Website: www.emedicinehealth.com

Medline Plus
 Website: www.nlm.nih.gov/medlineplus

National Kidney and Urologic Diseases Information
 Website: www.kidney.niddk.nih.gov

National Kidney Foundation
 Website: www.kidney.org

COMMONLY USED MEDICAL TERMS

Anal Retentive: A personality style described by the famous neurologist Sigmund Freud. This personality style is associated with extremes of personalities. Typically these individuals are very organized, structured and controlling. People with this personality may be super-achievers or referred to as having a type A personality. For the purposes of this book, children that are anal retentive tend to have tight pelvic muscles and tend to hold their urine and stool for longer periods of time due to their intense focus on other issues.

Anal Fissures: Cracks or tears in the anus. Anal fissures commonly occur with large or hard bowel movements. Anal fissures are common in children with constipation and are irritating, painful, and itchy.

Antidiuretic Hormone (ADH): A hormone made by the body. ADH causes the kidneys to make less urine when the body needs to conserve fluids. If a person has a low level of ADH at night more urine is produced while sleeping which may lead to bedwetting.

Anus: The external part of the body where stool comes out.Bedwetting Alarm: A device that alarms when it comes in contact with urine. It is also known as an enuresis alarm.

Bladder: The body organ that collects and empties urine. It is a muscular organ that stores urine under low pressure. The bladder's muscular lining contracts when it is instructed to by the brain to empty. The size of the bladder is usually proportional to a child's body size and age. Some children are born with larger bladders than others, but a general rule is bladder size (ounces) = age + 2.

Bladder Spasms: When the bladder has a sudden urge to empty. Neurological problems or infection may cause significant bladder contractions or spasms. In children with abnormal potty habits, the bladder is not able to fill and completely empty at normal intervals. These children's bladder muscles tend to get thicker and stronger because they attempt to empty against an abnormally tight sphincter. At times, the bladder will suddenly contract and try to empty, causing a spasm, without any other underlying abnormality. Bladder spasms result in stomach cramps usually below the belly button, pelvic pain or leakage of urine (incontinence).

Catheter: A plastic or rubber tube that is inserted into the urethra.

Conditioning: The act of learning by being exposed to repetitive stimuli or conditions that only occur during certain activities.

Constipation: Anyone with abnormally large, hard or painful bowel movements. Most children have an average of one bowel movement per day and anything less than this can be described as constipation. Constipation can result in belly pain, cramping, painful bowel movements and even bowel accidents (encopresis). Anal tears, bleeding, and itching can also result from constipation. Fecal staining of the undergarments acts as a hint that a child may have significant constipation.

Cystitis: An infection or inflammation of the bladder. The infections are usually bacterial (example E.Coli), and can result in significant urinary symptoms including frequency, burning, leakage, pelvic pain, and blood in the urine. Low-grade fevers may be associated with cystitis but are usually not greater than 101°.

Desmopressin: A medication containing Antidiuretic Hormone (ADH). The drug DDAVP® is a trade name for desmopressin (contains ADH).

Diurnal Incontinence: Voluntary or involuntary loss of urine (wetting accidents) that occur during the daytime. Nighttime wetting, or nocturnal enuresis, can be associated with diurnal incontinence. Any form of wetting accidents either very small (moist underwear) or large is referred to as diurnal incontinence.

Dysfunctional Elimination Syndrome: This literally means to have abnormal emptying of urine and/or stool (bad potty habits). Children with this problem, present with a wide variety of signs, symptoms, and complaints. These children commonly have problems with never using the restroom, using the restroom too often, urgently needing to go, holding and squatting, abdominal pain, soiled or stained underwear, blood in the urine, constipation and daytime or nighttime accidents of urine and or stool.

Dysfunctional Voiding: Children who have urinating problems without a medical explanation are referred to as having dysfunctional voiding. This medical term implies bad urinating habits without obvious problems with bowel movements. Now that bowel problems are known to commonly be associated with urinating problems, this term has been replaced by dysfunctional elimination syndrome.

Dyssynergia: Urologists and Pediatric Urologists use this term to imply the conflicting actions of the bladder and the pelvic muscles. When the

bladder or bowel tries to empty and the pelvic muscles or sphincters do not relax then there is a conflict. This results in pain, accidents, incomplete emptying, and any of the other complaints that are associated with bad potty habits.

Dysuria: Painful urination that is often described as having a burning sensation. Dysuria is common in children with urinary tract infections, irritated private parts, and bad potty habits.

Encopresis: To have bowel accidents. Constipation is commonly associated with encopresis.

Enuresis: To have urinary accidents during daytime or nighttime.

Fecal Impaction: A severe form of constipation that can result in a child's inability to have a bowel movement. The child becomes blocked with stool and may require a very aggressive bowel program to relieve the problem.

Frequency: When a person uses the restroom often. Urinary frequency is one of the most common problems in children with bad potty habits.

Gross Hematuria: To have blood in the urine that is visible. Gross hematuria usually implies some form of underlying problem such as stones, urinary tract infections, birth defects of the urinary system, or trauma.

Hematuria: Blood in the urine that is either visible or invisible.

Hesitancy: When one has a delay or difficulty starting a urine stream.

Imipramine: An anti-depressant medication that is commonly used for bedwetting. This medication also relaxes the bladder and tightens the urinary sphincter. Tofranil® is a trade name of this medication.

Incontinence: To leak urine or stool.

Intravenous Pyelogram (IVP): An x-ray that involves injecting dye through a needle that then circulates to the kidney. This test is used to evaluate the function of the urinary system.

Kidney: The body organ that filters blood and makes urine. The kidney cleans toxins out of the bloodstream, maintains hydration, and maintains proper blood pressure.

Microscopic Hematuria: Blood in the urine that is not seen with the naked eye. Blood can be detected in the urine by using a microscope or performing a "dip stick" test.

Nocturnal Enuresis: Bedwetting. It is the act of involuntary wetting (incontinence) at night.

Oxybutynin: An anti-cholinergic medication that is used for bedwetting. This medication relaxes the bladder and avoids bladder spasms. Ditropan® is a trade name for this medication.

Pediatric Gastroenterologist: A physician who has completed medical school, a pediatric residency, and a pediatric gastroenterology fellowship (pediatric GI). Pediatric residencies are typically 3-4 years and fellowships are an additional 2-3 years. Pediatric gastroenterologists diagnose, manage, and treat children with swallowing, digestive, intestinal, and liver problems. The most common problems they treat are Chrohn's disease, gastroesophageal reflux, constipation, abdominal pain and abnormal liver function.

Pediatric Nephrologist: A physician who has completed medical school, a pediatric residency, and a pediatric nephrology fellowship. The pediatric residency is usually 3-4 years and the nephrology fellowship is an additional 1-3 years. Pediatric nephrologists diagnose, manage, and treat children with problems related to the urinary system. Most commonly they treat children with abnormal urine tests, kidney failure, and kidney transplants.

Pediatric Urologist: A physician who has completed medical school, a urology residency, and a pediatric urology fellowship. The urologic residency training is typically 5-6 years and includes 1-2 years of general surgery training. The pediatric urology fellowship is an additional 1-2 years. Pediatric urologists diagnose, treat and manage problems related to the adrenal glands, kidneys, bladder, and urinary tract system in children. Commonly, pediatric urologist treat blockages in the urinary tract, vesicoureteral reflux, urinary tract infections, birth defects involving the urinary system, undescended testicles, genital abnormalities including intersex disorders, and bad potty habits (dysfunctional elimination syndrome).

Primary Nocturnal Enuresis: Wetting at night that started after potty training and has never stopped. Some believe this term implies a child has never had a dry night. Others feel this term applies to children who have never had a series of dry nights.

Pyelonephritis: An infection involving the kidney that is usually caused by bacteria. Children with pyelonephritis usually present with back pain, fever greater than 101°, poor appetite, and nausea/vomiting.

Rectum: The final portion of lower colon that controls the flow of stool out of the body.

Secondary Nocturnal Enuresis: Wetting at night that starts after a longer period of dry nights. It is referred to as bedwetting that is new and did not previously occur.

Sphincter: A muscle that wraps around the urethra and rectum. This muscle can tighten and hold urine in the bladder or stool in the colon. There are several sphincters that must be relaxed to allow the passage of urine and stool out of the body.

Stress Incontinence: Urinary leakage when coughing, laughing, or lifting. Children who leak with laughter are referred to as having "giggle incontinence".

Ureter: The very small tube that drains urine from the kidney into the bladder.

Urethra: The tube that carries urine from the bladder out of the body. The urinary sphincters and pelvic muscles wrap around the urethra and coordinate their activity with the bladder to either allow storage or emptying of urine.

Urge Incontinence: To have a sudden urge to use the restroom followed by urinary leakage. This is usually caused by not getting to the restroom quickly enough before having an accident.

Urgency: To have a sudden urge to urinate (and possibly have a bowel movement).

Urinary Tract Infection (UTI'S): Any infection involving the urinary tract, which most commonly is the kidney or bladder. Infections involving the ureters (kidney tubes) and urethra (bladder tube) are also considered urinary tract infections.

Urodynamics: A bladder test that determines the bladder capacity, bladder pressures, and urethral activity while instilling fluid into the bladder via a catheter (tube). It is usually performed by a urologist.

Vesicoureteral Reflux (VUR): When urine abnormally backs up the kidney tubes (ureters) during bladder filling and/or emptying. Vesicoureteral reflux, commonly referred to as reflux, is diagnosed during a voiding cystoure-throgram (VCUG). VUR is common in children who suffer from frequent urinary tract infections.

Voiding: The act of urinating.

Voiding Cystourethrogram (VCUG): An x-ray of the bladder and urethra. A tube (catheter) is inserted into the urethra and the bladder is filled with nuclear "dye". X-rays of the bladder and urethra are taken during filling and emptying.

EDUCATION
PRODUCTS
COUNSELING
RESULTS

1-877-POTTYMD
POTTYMD.com